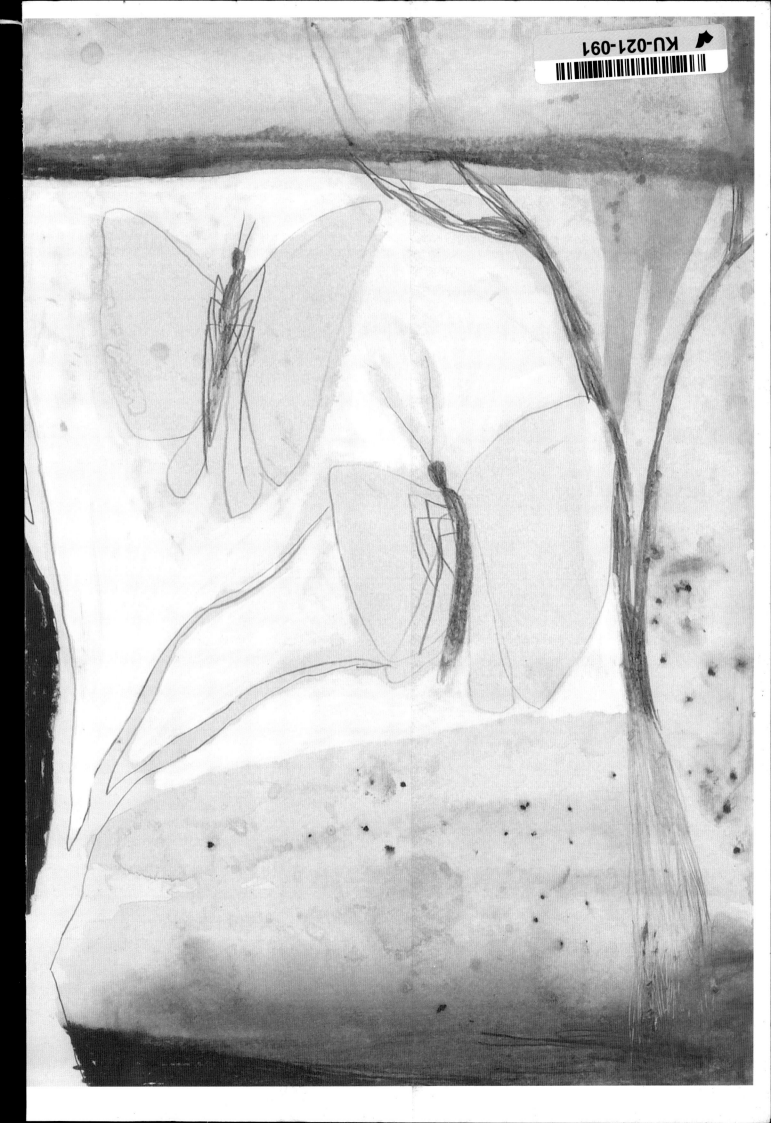

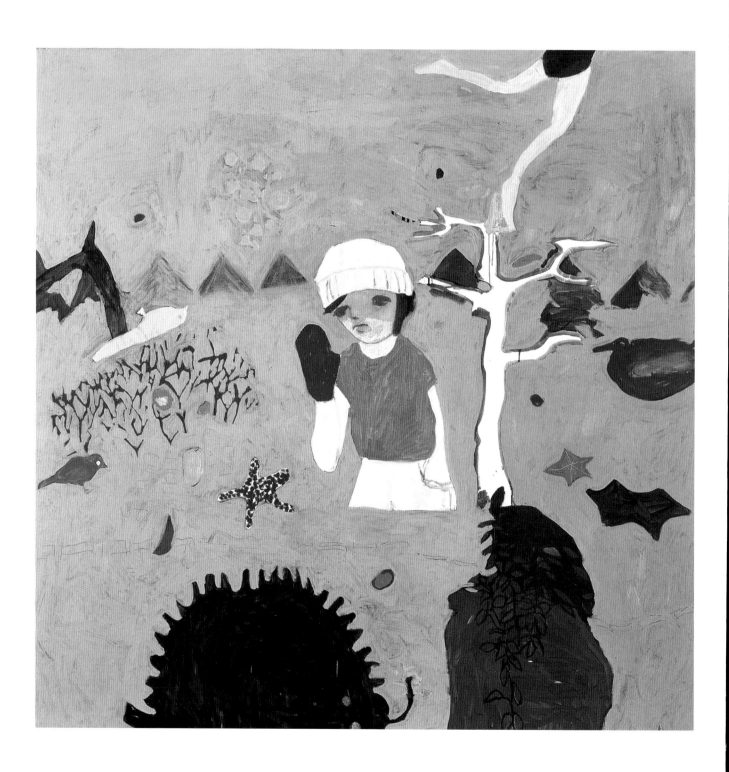

Above: Makiko Kudo. *New Pool*, 2002.
Oil on canvas. 116.7 × 116.7 cm. Private collection, Osaka.

Previous page: Kyoko Murase. *Moonlight Butterflies*, 2003.
Pigment and pencil on paper. 29.5 × 21 cm.
Private collection.

drop dead cute

the new generation of women artists in Japan

Ivan Vartanian

CHRONICLE BOOKS

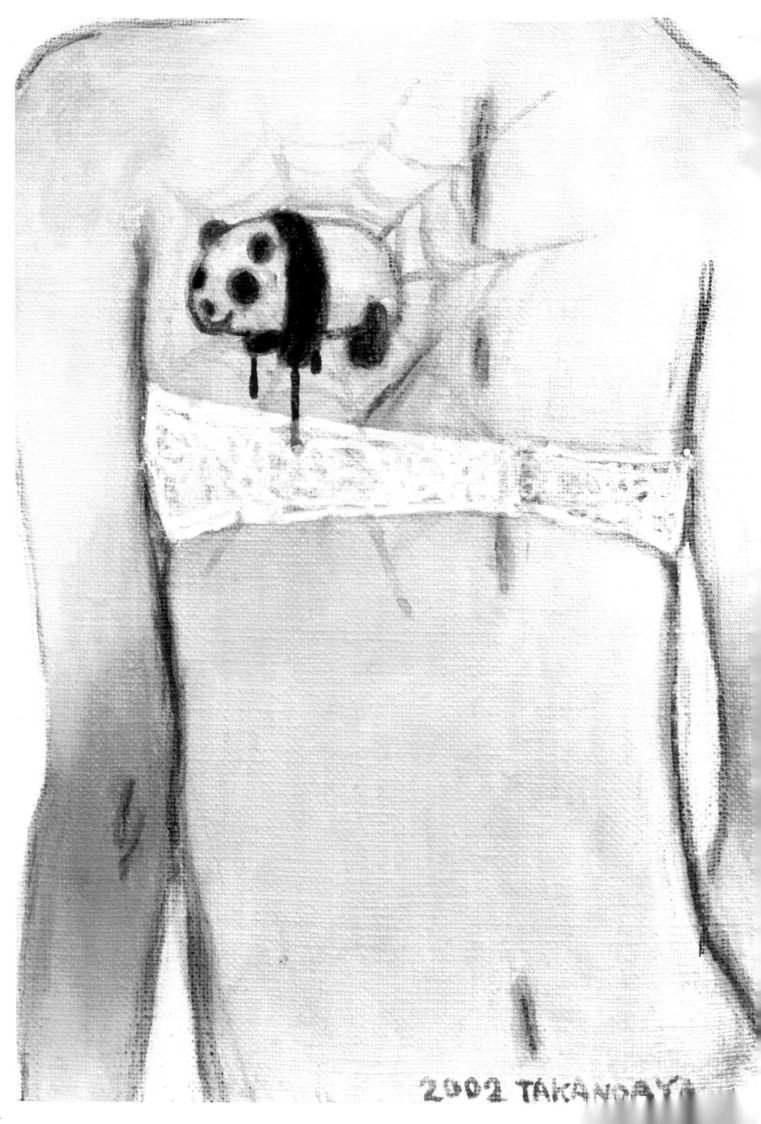

2002 TAKANDAYA

Aya Takano. *Kanojo no senaka*, 2002.
Acrylic on canvas. 22.5 × 15.8 cm.

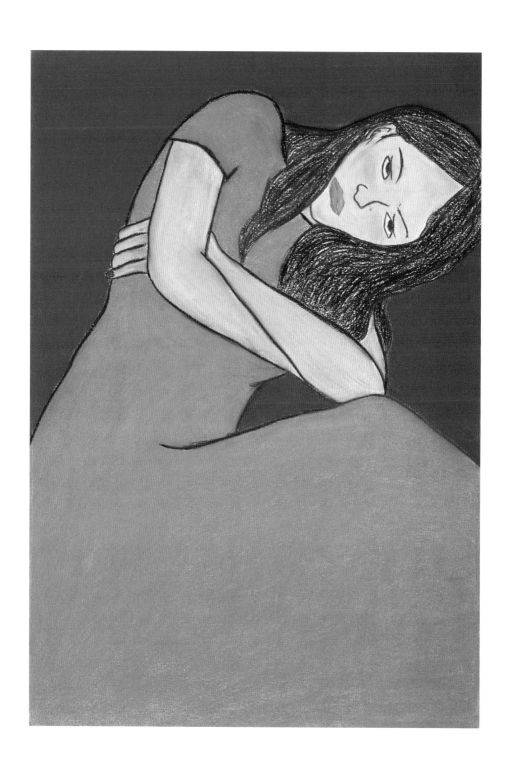

Introduction

by Ivan Vartanian

A Vanishing West

CUTE CHARACTERS AND CUDDLY animals seem an unlikely artistic vehicle for dark and complex emotion. Yet in the work of the ten artists in these pages, drawings and paintings that seem on the surface blithe in spirit and execution are given an emotional gravitas typically reserved for more representational narrative artwork. Here, a mixture of fantasy and reality is rendered in a style reminiscent of children's primitive sketches—simple line drawings made with an apparent lack of dexterity—and the border between what is imagined and what is real is blurred. These artists represent a new generation in Japan, born of the same movement that launched artists Yoshitomo Nara and Takashi Murakami to international acclaim. This is a generation greatly self-possessed in style and subject matter, and the work's charge is uniquely Japanese yet personally powerful, transcending simple boundaries.

The ten Japanese women artists included here are at the forefront of this new wave of creativity, and the images selected for this book focus on their recent work. Though almost all of the artists are relatively young, we have also included work of the pioneering artist Yayoi Kusama, whose recent dramatic shift in subject and style underscores the trends that are accelerating in the contemporary Japanese art world. Though her work is in a sense independent of outside influence, Kusama too has found an "off ramp" into the world of cute. Where the general character of her sculptures and paintings can be seen as utterly devoid of sensuality, her recent drawings have a warmth and playfulness previously unseen in her oeuvre. Kusama's recollections of a childhood fraught with difficult family relations are recast in a happier light here. Likewise, for Makiko Kudo, childhood remembrances serve as the basis for her paintings and drawings. In Kudo's work the world is as mysterious as it is sensory. Because these artists are mostly so young, it's natural perhaps that they work with not only youthful figures, but also themes relating to childhood memories.

The connection of animals and emotions is one prevalent theme that may also stem from childhood. Here we see animals depicted not as others, but as integral to the human emotional landscape. At some level (as in the works of Makiko Kudo and Yuiko Hosoya), animals represent an ideal of peace and comfort, as if our relationship with them is what brings us in touch with ourselves and makes us real. The baby elephants of Chinatsu Ban's paintings also do the same in addition to accessing an overt sexuality. By helping us to reestablish engagement with our own emotions, animals may paradoxically have a humanizing effect.

Yuiko Hosoya. *Untitled*, 1997.
Dry pastel on paper. Approx. 65 × 50 cm.

Reflections upon the body and its place in nature are prevalent here as well. In Kyoko Murase's work there is a sense of communion with nature, as her limp figures are nestled by waves or inundated in cascading light. Ryoko Aoki takes this one step further with scenes in which the female body seems to share forms with elements from nature.

Men, on the other hand, are (with one exception) notably absent from the work assembled here, in terms of both theme and subject matter. Even Kusama, whose notorious phalli in past work were evidence of a direct and continued consideration of sex, has now redirected her focus and her "hysteric" energy toward the splendor of female youth. Whatever sexual or erotic themes may surface in the works shown here are generally handled allegorically or metaphorically—as clearly seen in the computer-rendered illustrations of Chiho Aoshima. Sexuality engaged in this way, without a specific object of focus, is in stark contrast to the overtly sexualizing work of male artist Makoto Aida (for example) [Fig. 1]. In Aida's art, the aesthetic of the *otaku* (the Japanese term once used as an epithet for socially inept and hobby-obsessed young men with only a tenuous grasp of reality) is played out to its full fetishistic extent. In addition to the commonplace appetite for girls in bikinis, unnaturally attenuated limbs, and gravity-defying breasts of gargantuan scale, the *otaku* have a penchant for sailor-suit school uniforms, accessories such as capes, wings, and helmets, long (preferably blue)-haired girls with an impressive mastery of martial arts, role-playing, and of course saucerlike eyes. The women whose work is collected here present approaches to female gender and identity that have little in common with such objectifying and otherwise predominant tropes.

The theme of exclusion plays a key role in the work of Yuko Murata's nature scenes. While other artists are concerned with subjects and themes that are close at hand, Murata's full attention is turned toward distant lands and idylls. Though an urbanite herself, she has avoided any sense of the city, or for that matter civilization, in her work. In this way, Murata's art provides a counterpoint to Tabaimo's scenes of urban turmoil.

The clear contrast between city and nature falls along the lines of a broader dichotomy addressed by many of these artists: the real versus the unreal. Each of these women approaches the limbo place between the two realms in her own manner, whether through theme, medium, or style. Interestingly, the world of manga—ubiquitous in Japan—is very much concerned with this crossroads of reality and unreality. In Japan, manga accounts for nearly 40 percent of all printed matter. As publishers strive to expand their audience, the manga "industry" has become more finely attuned to nearly every demographic imaginable, and some of the most accurate depictions of daily life in Japan are found in its subgenres. There are manga periodicals that cater to players of pachinko and go, fishing aficionados, and an endless list of other hobbyists; self-published manga dealing with the personal lives of its creators and produced for only a handful of dedicated readers; and erotic manga, which is similarly diversified to appeal to innumerable tastes.[1]

While there is a plethora of titles featuring fantasy heroes, robots, and the like, there is little that is "comic" in most Japanese manga. And though melodrama and pure fiction are certainly the norm in manga, the situations depicted are usually far from extreme. Two best-selling manga in the recent past have been about the frustrations of a typical construction worker, and

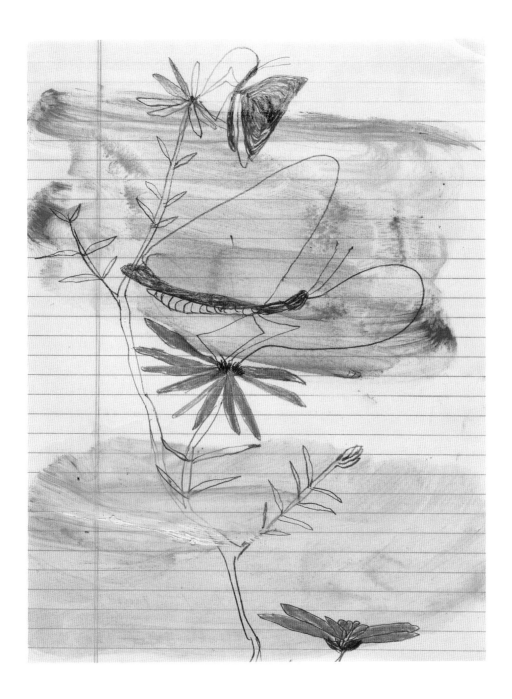

about the office dramas of a young "salary man" (office worker) with superlative skills. In city metro cars (a common venue for advertisements of weekly and monthly manga periodicals of all genres) it is not unusual to find photographs of celebrities posted side-by-side with their manga rendering. Though not everyone in Japan reads manga, it is so widespread as a cultural phenomenon that it may well be the cause of the culture's evident preference for the drawn image, as opposed to the photograph (this drawing/photography duality is addressed in Chiho Aoshima's composite works). This tendency is not entirely unknown in

Kyoko Murase. *Flower Juice*, 2003.
Pigment and pencil on paper. 28 × 21.5 cm.
Collection of Tomio Koyama.

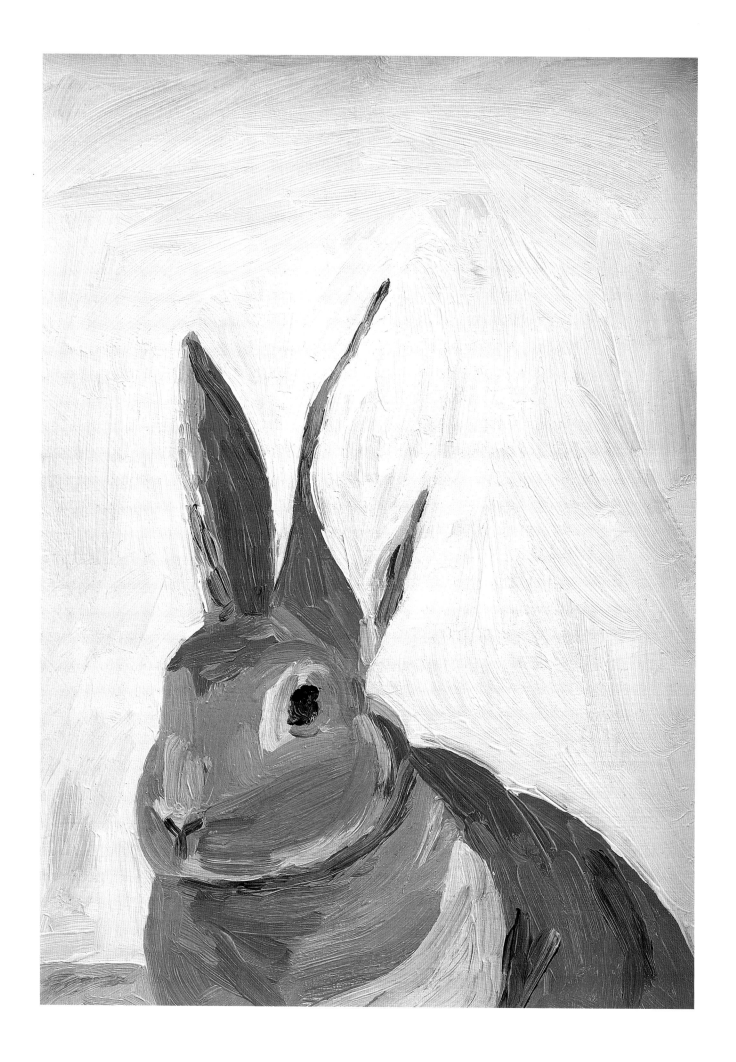

10 Yuko Murata. *My Friend's Rabbit*, 2004.
Oil on board. 29.5 × 21 cm.

Western popular and high culture, but its effects in Japan are truly remarkable. There is an understanding of the "embodiment of the real" in the drawn image here that is quite unique: drawing in Japan takes on a representational function that is far more concrete than that traditionally accorded it in the West.

There is a certain ease with ambiguity in Japanese culture, and thus this gray area between reality and the unreal is comfortably accepted. Tabaimo finds a relation between this acceptance of ambiguity and the culture's social problems—the very term *otaku* was coined in reference to those recluses whose interests and hobbies extend to obsessions, potentially leading to sociopathic behavior. Horror-manga masters Junji Ito and Kazuo Umezu have influenced Tabaimo's work, which includes distressing scenes taken from real-life events of violence and crime. The real and unreal are also combined in Murata's paintings of nature and animals, based on photographs from travel brochures. She takes these archetypal images of faraway, unspoiled nature, and transforms them into something between reality and imagination. Her landscapes and animals become patches of color (soft-edged, like living creatures), but retain their connection to photographic representation. Murata converts these versions of nature, which in other hands might seem absurd in their idealism, into something approachable and attainable, and often cute.

Much has been made of Japan's *kawaii* or "cute culture" in the West, where it is taken up in forums of earnest academic discussion and has become a byword for international ravers outfitted with Sanrio licensed goods. Though it usually refers to things adorably diminutive, *kawaii* can be used more broadly to define anything that draws out an empathetic response. In part, it is a taste for elements of childhood incorporated into adult life. In Japan, the industry of cute has flourished in the form of cartoon characters so integral to the society that even Tokyo's police department has its own character mascot (Peepo-ku). On a cultural level, characters function as means of "getting in touch with one's emotions" and have become a kind of tool for bringing internal psychic machinations out into the open.[2]

But *kawaii*, of course, has a flipside. In its appeal to our experience of "innocence," and to our empathetic nature, it is emotionally charged, and its occasional propensity for gore (as in the work of Aoshima and Tabaimo) thus seems pointedly brutal. Considered within its larger context, "cute" takes on a certain introspective valence. Cuteness, though ostensibly devoid of irony, does not negate darkness, and can in fact be a means to accessing darkness, as characters become loci of emotion and identification. A clear example of this emotional tenor can be found in the work of Yoshitomo Nara [Fig. 2]. His paintings of *enfants terribles* and sculptures of glum dogs make a psychological impact that belies their veneer of innocence. His work conveys a reality that can be powerfully experiential for the viewer.

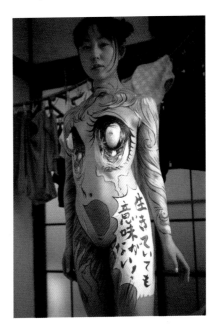

Fig. 1: Makoto Aida. *Girls Don't Cry*. 2003. C-print. 100 × 69 cm.

11

The distinct form of realism that is found in manga dovetails with the emotional provocation of cute characters. Both manga and *kawaii* testify to the prominence of drawing in Japan's visual repertoire. Most of the artists in this book cite the direct influence of manga upon their own work. Though popular culture has had a profound effect on these women, there are also thematic and formal aspects in their work that reach back to classical Japanese influences. One of the fundaments to rendering something "cute" is to play with proportion and scale, thereby distorting the subject. (The *otaku* vision of grossly exaggerated human figures takes this to an extreme, and has become a fetish in its own right.) This artistic habit of warping is a central element of Japanese aesthetics—as seen in the brush drawings of Jakuchu

Ito of the Edo Period—and it is a technique frequently seen in the work of the artists represented here. The relative proportions and dimensions of animals, for example, while not distorted to cartoonish hyperbole, are rendered with a degree of exaggeration that gives them their charm; this is particularly evident in the work of Aya Takano.

Takashi Murakami has incorporated deformation and transformation as fundamental features of his oversized, three-dimensional figures. His character DOB-kun is depicted as a whirlwind strained under the power of its own centrifugal force [Fig. 3]. In *My Lonesome Cowboy*, a stream of ejaculate lassoes around what looks like the protagonist of an anime. And in one of his garage-kit assemblages, a fighter plane transforms into the shape of a woman. Though the

Yuiko Hosoya. *Put that Peach in My Pocket*, 2003.
Pencil on paper. 29.7 × 42 cm.

Ryoko Aoki. *Circle*, 2004.
Ink and felt-tip pen on paper. Triptych: 52.4 × 36.5 cm each.

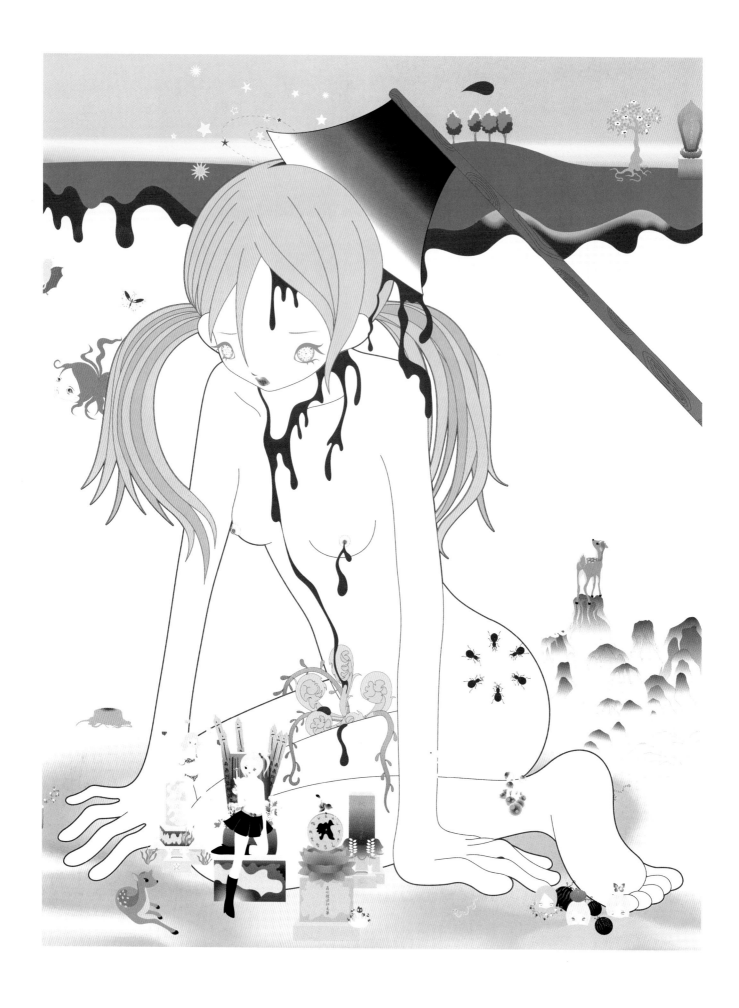

Chiho Aoshima. *The Birth of a Giant Zombie*, 2001.
Inkjet print on paper. 630 × 1977 cm (detail).

subject matter may be the feedback from pop culture, the form it takes has aspects that recall Japan's artistic history. Art critic and scholar Midori Matsui summarizes Murakami's work in this way: "Traditional Japanese painting disrupts realistic representation and narrative continuity by exaggerating the idiosyncrasies of individual lines and designs, applying ornamental stylization and distortion of landscape, people, and animals . . . 'copying nature.' Murakami claimed that this creation of an autonomous aesthetic space within the framework of realistic representation . . . is the radical spirit of the Japanese two-dimensional aesthetic."[3] Making this connection between the formal aspects of nineteenth-century Japanese painting and the contemporary world of *otaku* allows the artist to wholly circumvent more than a hundred years of Western art and its influence on Japanese aesthetics and culture. Matsui writes, "By presenting a hybrid of pre-modern and postmodern figurative excesses, Murakami revives the domestic sensibility previously repressed by modern Japanese high culture in favor of spiritual depth."[4]

This enterprise of conflating the craftwork of old Japan with the pop culture of new Japan is known as "Superflat." When Murakami coins the phrase "The Meaning of the Nonsense of the Meaning" (the subtitle of his monographic publication[5]), he is referring to the time in Japanese *geijutsu* (craft) that predates the influence of Western art and whose primary role was decorative. *Nihonga* (Japanese painting) developed as a concept in response to contact with the forms and themes of Western art. Japanese *geijutsu*'s apparent lack of "meaning"—so intrinsic to Western art—relegated the traditional ornamental style to secondary status in both the eyes of the West and the Japanese themselves. Only in the light of the imported *other* did

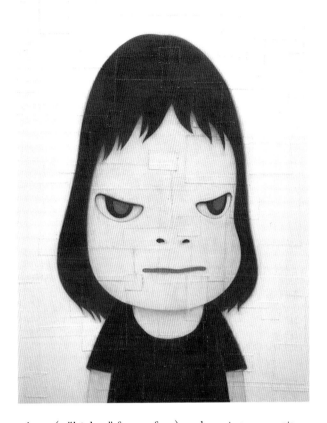

nihonga (a "higher" form of art) coalesce into an entity—but the terms for *nihonga* were likewise dictated by Western art and aesthetics. Murakami's art now turns the tables; he has the home-field advantage, returning to the features of classical Japanese art—revisiting the perspective of *ukiyo-e* and the intentional distortion of natural forms, for example—and in so doing creating a "hyperspace" where the old mixes with contemporary culture. So divergent are the sensibilities toward composition, line, color, form, medium, context, and import in this new amalgam that it seems the West has lost its position as the shadow other. The Japanese, in fact, are way out in front.

Tokyo has become an epicenter of activity and ideas that have led to the genesis of what Murakami calls "Tokyo Pop."[6] He identifies amateurism, childishness, and cheap-looking production as the bases

Fig 2: Yoshitomo Nara. *Little Ramona*, 2001.
Acrylic on cotton. 130.3 × 96.8 cm.
Private collection, Tokyo.

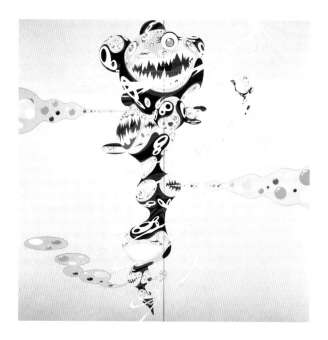

for the originality of contemporary Japanese pop art. In his 1999 "Tokyo Pop Manifesto" for a new generation of artists and musicians, Murakami set forth three central concepts: 1) The closeted worlds of the *otaku* have been externalized, creating an era of *Post Otaku* (*Po-Ku*, for short). 2) The forefront of manga production is erotic manga; hence *Eropop* refers to the prevalence of erotica in *otaku* aesthetics. 3) *H.I.S.-ism* (*His-m*, for short) is the widespread access to travel abroad. Inexpensive travel was made possible by travel agencies such as Japan's H.I.S., which thereby stimulated much introspection and reflection on Japanese identity. What was once covert has become overt. The internal has become external. Kyoichi Tsuzuki's photographs in *Tokyo Style* are part of this too, showing the normally hidden interiors of typical Tokyo apartments. By turning the attention to things domestic, objects near at hand, and the matter of daily life, Tokyo Pop establishes a new breeding ground for art in Tokyo that eclipses the influences of the West while creating a milieu for domestic aesthetics to flourish.

The expanding art markets in Tokyo and Osaka have helped foster a new and growing infrastructure for promoting contemporary art and reversing the "amateurism" that has characterized Japanese art for generations, thereby allowing it to now take shape as a professional industry. This process has been partly set in motion through the close affiliations Japanese galleries have fostered with their Western art world counterparts. The gallery system has grown in scope and scale, as have licensing, promotion, and commercial tie-ins. Both Chiho Aoshima and Aya Takano, for example, have collaborated with Naoki Takizawa, lead designer of the brand Issey Miyake, to create clothing patterns for several of the women's prêt-à-porter collections. This was a project engineered by the Kaikai Kiki Co. artists' collective and agency (www.kaikaikiki.co.jp), founded by Murakami, which both employs and represents Aoshima, Takano, and Chinatsu Ban. Initially created to manage the many artist-assistants needed to create Murakami's large-scale work, Kaikai Kiki has blossomed into an agency and means of collaboration for those artists, aiding in the production and distribution of their own work. Takano is quite clear about her appreciation of what Kaikai Kiki has done for her career: "I'd otherwise probably still be doing small illustrations for magazines." Aoshima is a production manager, while Ban works in administration. Kaikai Kiki also produces "Geisai" (a neologism combining the Japanese words for *craft* and *festival*), a semi-regular event started in spring 2002 and held in a Tokyo exhibition hall, where any artist may rent a booth and sell his or her work directly. This provides an opportunity for aspiring artists to be scouted by agents and galleries, as well as to see that their creations have a commercial value,

Fig. 3: Takashi Murakami. *The Castle of Tin-Tin*, 1998. Acrylic on canvas on board. 300 × 300 cm. Private collection, Los Angeles.

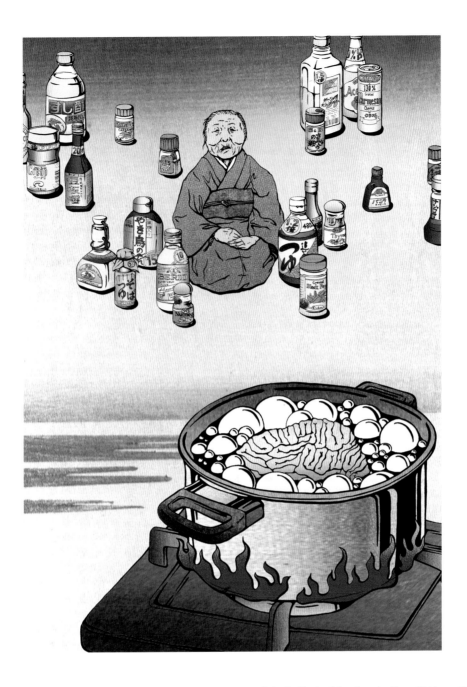

and that there are means to support themselves as working artists in Japan.

With these developing infrastructures comes a parallel growth in self-reliance, which is manifest in the themes and content of the art itself. This new generation of artists brings with it an originality that is indigenous to Japan. With that originality comes an authentic power, which has never before been this broadly visible, or for that matter, this cute.

1. Schodt, Frederik L., *Dreamland Japan: Writings on Modern Manga*, Berkeley: Stone Bridge Press, 1996.
2. Kayama, Rika and Bandai Character Research Center, *87% no nihonjin ga kyarakuta wo suki na riyu: naze gendaijin ha kyarakuta nashi de ikirarenai no darou?* (Why do 87 percent of Japanese like characters?), Tokyo: Gakken Research Publishing, 2001.
3. Cruz, Amada, Midori Matsui, and Dana Friis-Hansen, *Takashi Murakami: The Meaning of the Nonsense of the Meaning*, Annandale-on-Hudson, NY: Center for Contemporary Studies Museum, Bard College, 1999.
4. Ibid., page 24.
5. Ibid.
6. Murakami, Takashi, "Dear Sir, Are You Alive?—Tokyo Pop Manifesto," *Koukoku hihyou*, no. 226, (April 1, 1999): 58–59.

Tabaimo. *Japanese Kitchen*, 2003.
Original drawing for print.

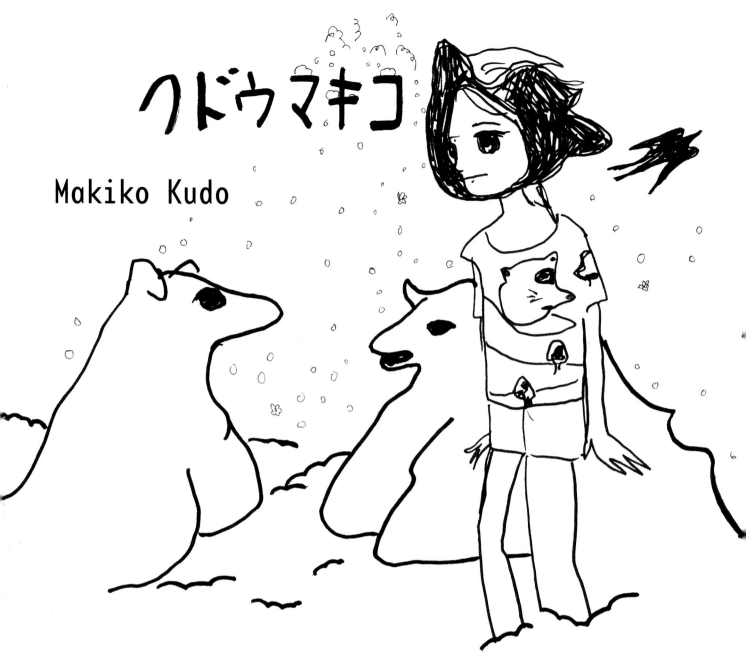

クドウマキコ

Makiko Kudo

CHILDHOOD EXPERIENCES, OF COURSE, stay with us long into our adult years. As children, we are so small that the world seems infinitely large and full of the unknown. There's much that evades our understanding—and thankfully so. Kudo's paintings and drawings bring to mind the bliss of youth; her images are steeped in childhood reminiscence.

She says, "I grew up in Aomori-ken—you've probably never heard of it—until I was in junior high school. It's in the country, in the north, so there was lots of snow. My grandmother had an apple orchard and there were lots of butterflies. My mother and I lived in a small house in the middle of the orchard. There was nothing around. About all I did then was doodle and chase after cats. I was no good at playing with other kids. I wanted to play with animals but I wasn't able to communicate so well with them and I wound up just chasing them about. The conversation was all one way." Kudo's paintings are suffused with the special connection that youngsters often feel for animals, triggering

アパートに住んでいる。建てかけっぽいそまつなアパート。でも少し広め。となりのとなりは空べやだ。雪が積もっている。向かいの家の屋根で男子2人がふとんを運んこんで今夜屋根の上で寝るとかいってもり上がっている。今日はお母さんと町内会の会議に出る約束なので出かける。アパート全体で1つの玄関でくつをはく。ひものない新しいくつ。背後に気配を感じてふり向くと、アパートの住人の若い男の子で、ゆっくりにこっとほほえみかけてくる。何でか分からない。外は凍っていてすべってばかり。まち合わせの文房具屋の前まで歩く。もうすぐらい。これからスノーボードに出かける人達が車に荷物をつめこんで、私にもできるかなー。「できると楽し〜よ」とかいって。車にはそりもつめこまれていた。

文房具屋と着物屋とCD屋と本屋とおかし屋がいっしょになった店はおばさんが1人でやっていて。私はおかしをじっと見ていた。そのうちお母さんがやって来て。テーブルにそんなにおいしそうでもないチョコレートケーキを2つ置く。

a host of memories and emotions—a connection that isn't always so one-sided. Sometimes, as in *Hot Summer Morning*, animals may do something considerate, like nudge a kid awake so she'll be on time for school. Cats in Kudo's work commonly seem to be getting themselves lost, and needing to be found. The lost-cat theme is taken to a more dramatic (and more menacing) level in *Going Tiger Hunting*, in which a little boy in school uniform sneaks into the jungle under cover of darkness, seeking a tiger.

Kudo's compositions, which she calls "chaotic," follow the playful logic of dreams, where the various parts fit together according to a pattern that is beyond the conscious mind. She's reluctant to explain her paintings (as some are reluctant to interpret the riddles of their own dreams), but she does say of *That Sort of Season*: "The penguins are from a dream I had. I went searching for a cat in the middle of the night. There was a factory of some sort. The wind was blowing through the grass. The cat was sleeping in a shallow hole

dug by a watchdog. I said to the cat, 'Okay, we're going home now.' But when I picked him up, I noticed there was a river, and on the other side of the river there were a lot of dead penguins. When I told my mother what I saw she said, 'It's that sort of season.' It's a good dream, I think."

And what does her mother think of her paintings? "She doesn't understand them," laughs Kudo. "All she says is that they look like manga. Or in one case she kept telling me the painting wasn't finished and she wanted me to correct a certain area. One time she griped too: 'Don't always draw cats you don't know. Draw our cat for once.'"

The clearly outlined shapes and absence of shading give Kudo's paintings and drawings the effect of flatness. At the same time, the subtle demarcation of foreground gives this lack of dimensionality the feel of a "floating atmosphere" that contributes to the dreamlike structure of her narratives. The organization and components of her compositions rely on oneiric logic too. Two children daydream in a field of penguins as a school of fish swims by in *New Season is Coming*. The fish, the children, and the penguins all operate in separate layers that fit into one another like interlocked constellations.

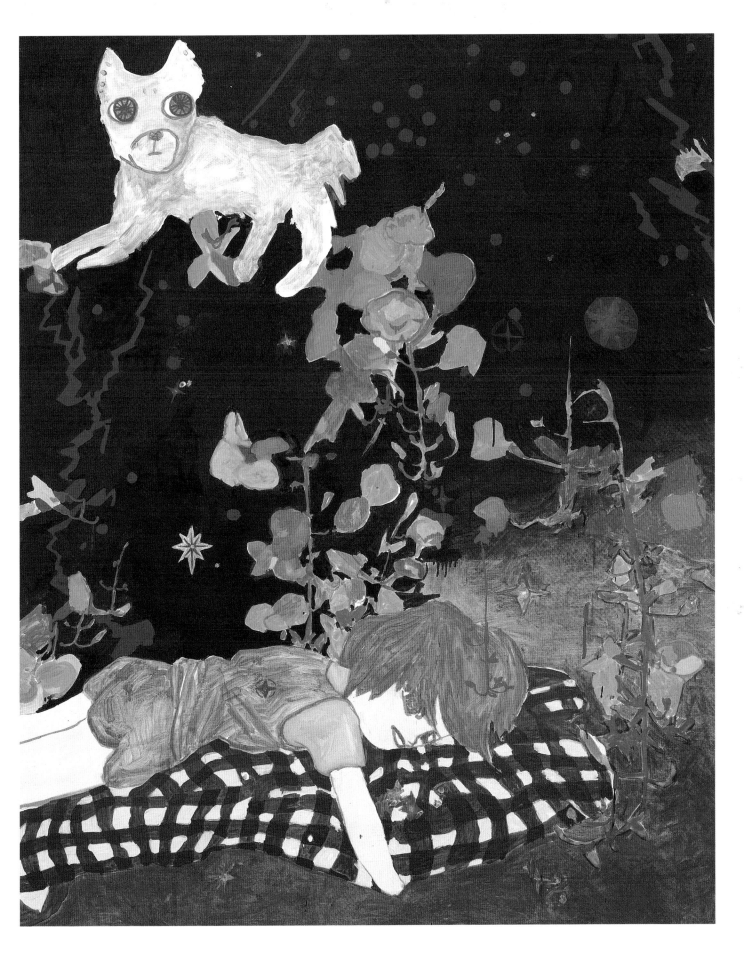

犬って ひとめぼれするんだってさ

Dogs Fall in Love at First Sight, You Know, 2003.
Oil on canvas. 162 × 130.5 cm.
Collection of Satoshi Shiraki and Michiyo Kamata, Tokyo.

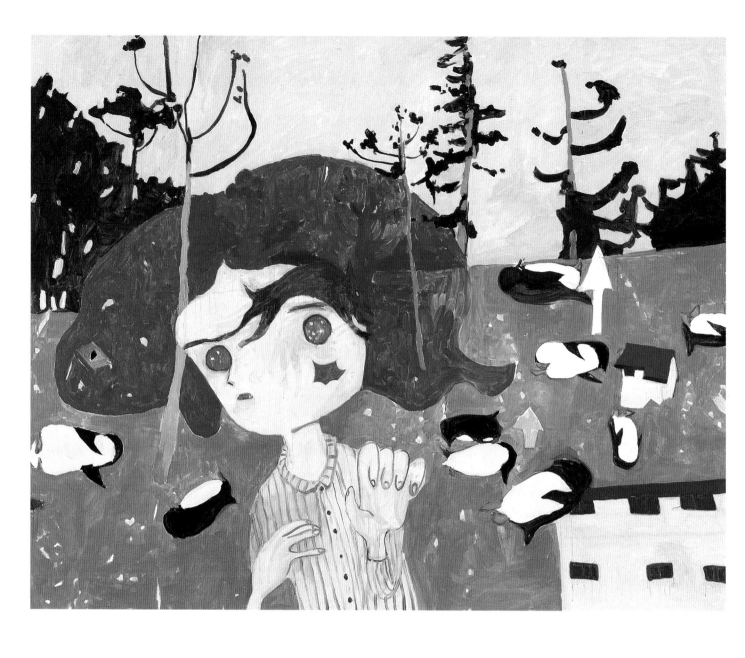

That Sort of Season, 2003.
Oil on canvas. 130.6 × 162 cm.
Collection of Tomoyuki Tachibana, Tokyo.

そういう季節

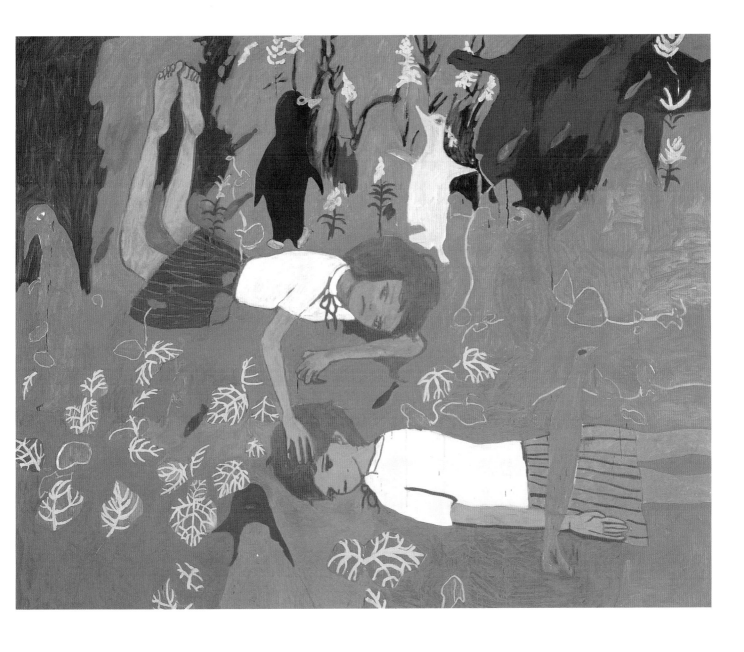

もうすぐ衣替え

New Season is Coming, 2003.
Oil on canvas. 181.9 × 227.3 cm.
Collection of Ryutaro Takahashi, Tokyo.

23

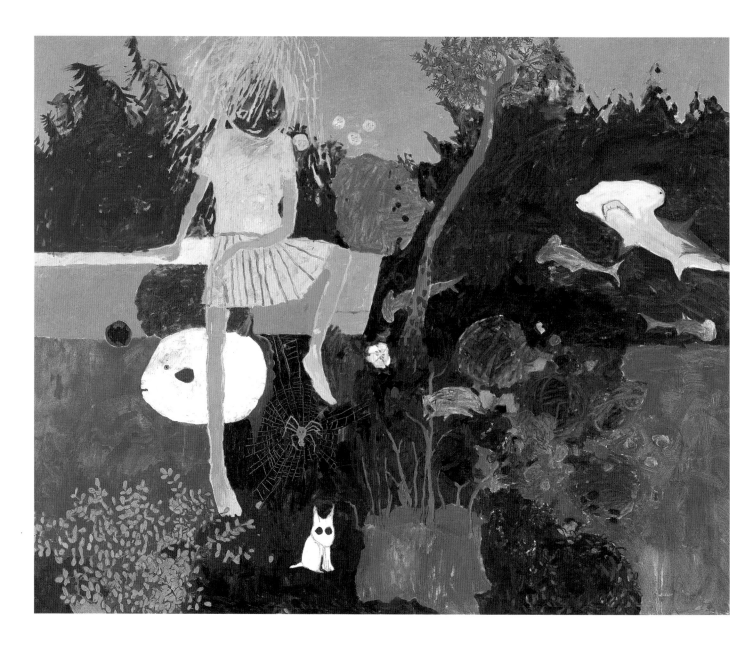

Getting Lost, 2001.
Oil on canvas. 182 × 238 cm.
Private Collection, Saitama.

まいご

24

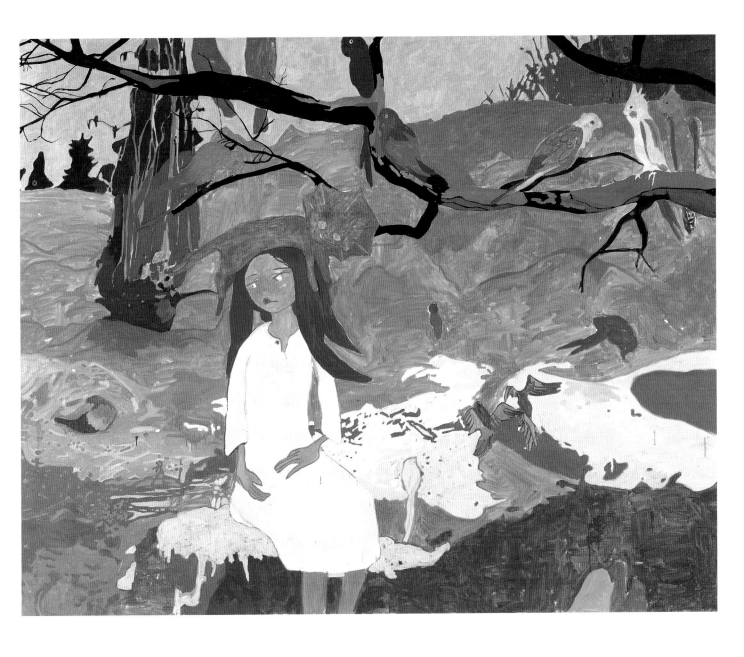

私たちは 銀河の 住人

We Live in the Milky Way, 2004.
Oil on canvas. 182 × 227 cm.
Olbricht Collection, Essen.

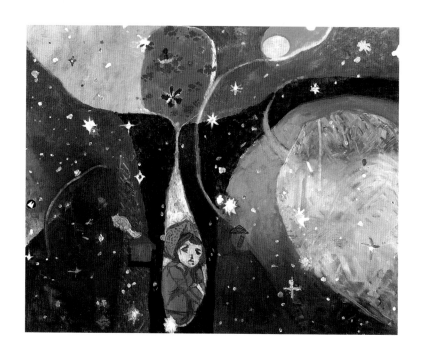

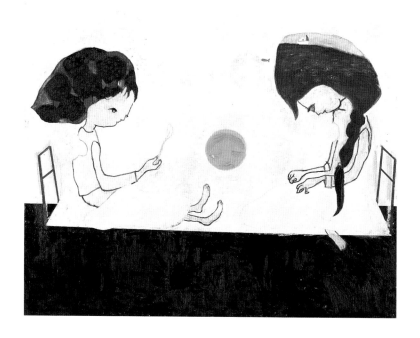

Chasha Cat, 2001.
Oil on canvas. 80.5 × 100 cm.
Private Collection, Saitama.

The Day of Yellow Soup, 2001.
Oil on canvas. 130.5 × 162 cm.
Collection of Marianne Boesky, New York.

チャシャ猫

黄色いスープの日

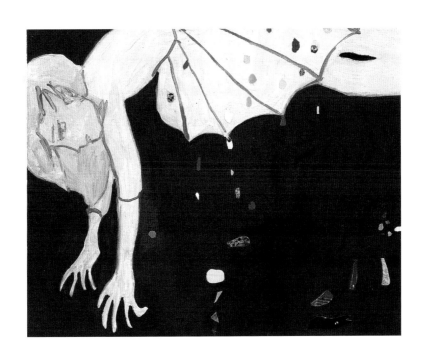

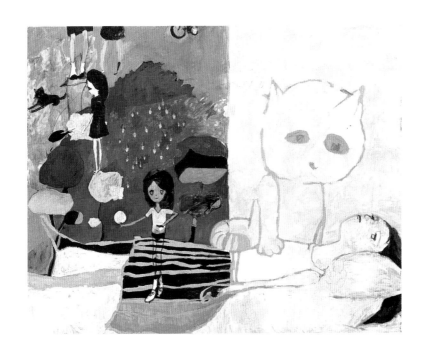

Kasa ma-sakasama, 2003.
Oil and collage on canvas. 48.7 × 60 cm.
Collection of Tetsuo Sugita, Tokyo.

カサマッサカサマ

Hot Summer Morning, 2001.
Oil on canvas. 130.5 × 162 cm.
Private Collection, Saitama.

あつい朝

27

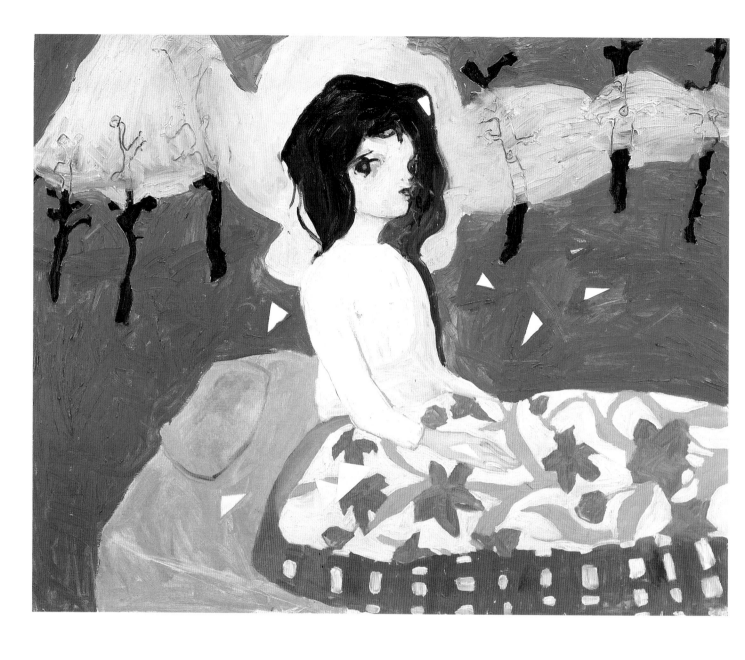

A Ship of Winter Shogun, 2002.
Oil and collage on canvas. 80.5 × 100.5 cm.
Collection of Galleri Faurschou, Copenhagen.

28

冬将軍の船

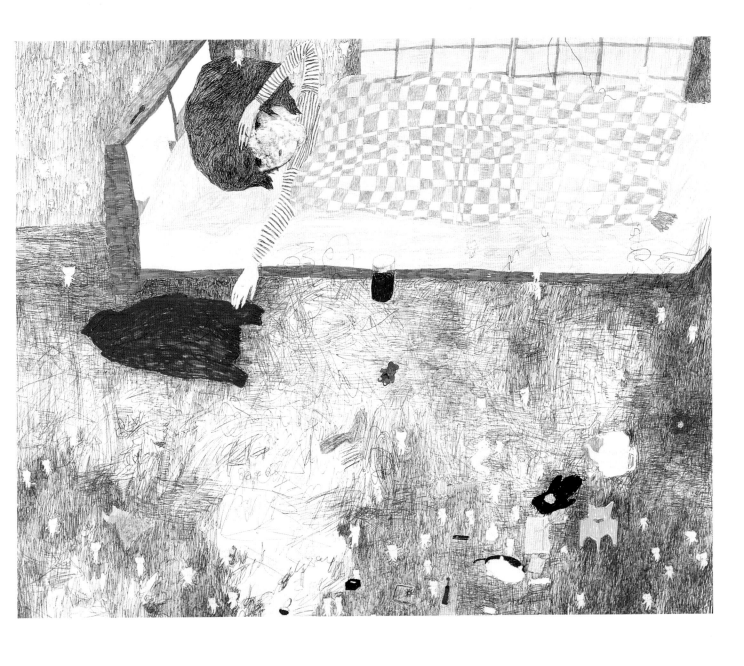

Flu, 2001.
Color ink, pencil, and color pencil on paper on board. 80.5 × 100 cm.
Private Collection, Tokyo.

インフルエンザ

虎を盗みに行く

Going Tiger Hunting, 2003.
Oil on canvas. 130 × 162 cm.
Private collection, Chiba.

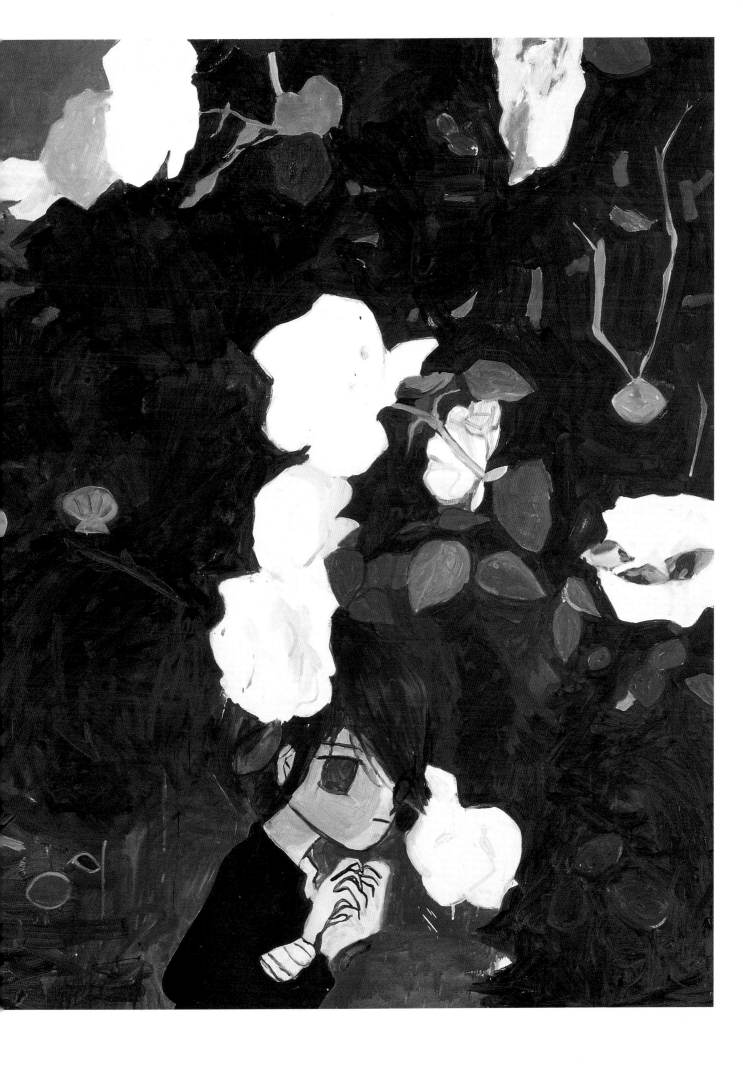

Chiho Aoshima

In Aoshima's work, we see a grim and sometimes gruesome world. Ghouls lurk in ramshackle homes. Spirits of the dead rise from crypts. Mummies and zombies walk the earth. A possessed-looking figure hovers in midair. A girl's internal organs float outside her body. Scenes of destruction, conflagration, and decay abound. But rather than terrifying or repelling the viewer, the figures in Aoshima's work are quite endearing. And there is little if any shock value in her tableaux, despite the graphic nature of her depictions. "Duality is extremely important," she explains. "Happiness comes at the cost of going through something really tough—and then it lasts just for a moment. That's proof of our being alive. Truly valuable things and being aware of life's small joys requires the experience of grief and bitter suffering. Overcoming such hardships leads to maturity and humility." So, instead of reveling in the horror and splatter, Aoshima underpins her use of the arch-macabre with something far more subtle—zombies and ghosts, for example. As the "living dead," they represent a horror of the human self; one's

own body has become the field of a grotesque transformation, beyond control. "The universe has a strong presence in the body—bringing you to tears even. The sight of a wound healing, for instance, is quite amazing. The changes that happen in the body are reminders that we are living together with a mass of cells."

In Aoshima's *Renaissance, Snake Woman*, a python consumes a woman and we see her body pass through the snake's digestive tract before emerging anew. The image has a sexual charge and—as with her pictures that deal with the grotesque—a more broadly metaphorical reading is also possible. Despite a palpable aura of the erotic in her work, there are no men in Aoshima's images (an aspect her work shares with that of the other artists in this book.) "When representing love, it doesn't matter if the object of that girl's feelings is another girl, a snake, or a bug, or a plant. Besides, the type of guy that I like I cannot draw, so there aren't any men. What inspires me are all fauna, insects, animals, the universe, and nature." From a Western perspective, there would seem to be strong

influences of manga and anime on her work, but Aoshima denies this. "I really don't read manga or watch anime, so actually there shouldn't be any connection." Nonetheless, the two-dimensional composition and the placement of elements in the visual plane are quite Japanese. "There isn't anyone in particular who has influenced me, but yes, I look at traditional Japanese paintings a lot. Those artists had sharp eyes." In *The Birth of a Giant Zombie*, Aoshima breaks up the space of her images into several sections that all work individually, but are also linked through the use of

mistlike gradations. These image elements recur in other works, further linking parts to a whole. Her paintings, which can be wall size, often employ effects of telescoping perspective through detail and scale—effects she's able to realize through computer illustration. "Certainly, compared to now, my older [image] files were quite simple. But at the same time, they have a weird, reckless quality. Before, I was really attached to the details of simple forms, but now I concentrate on creating individual worlds within my images."

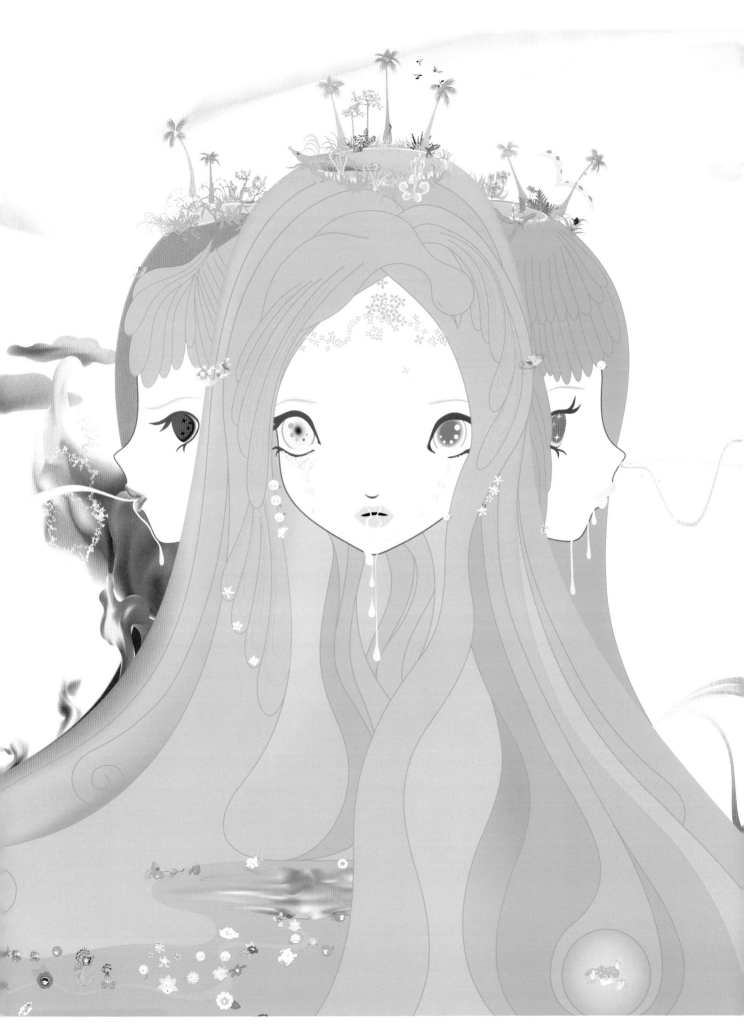

Mountain Girl, 2002.
Inkjet print on paper. 350 × 600 cm (detail).

マウンテンガール

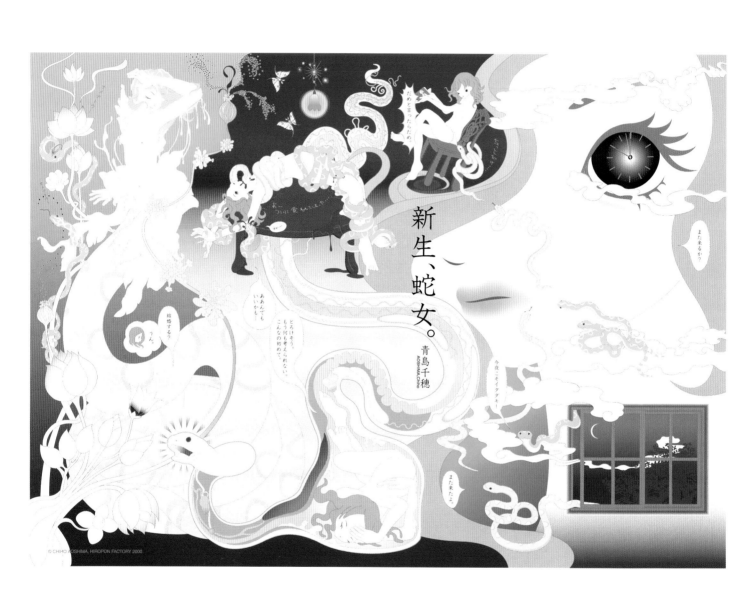

Renaissance, Snake Woman, 2001.
Inkjet print on paper. 29.7 × 42 cm.

新生、蛇女

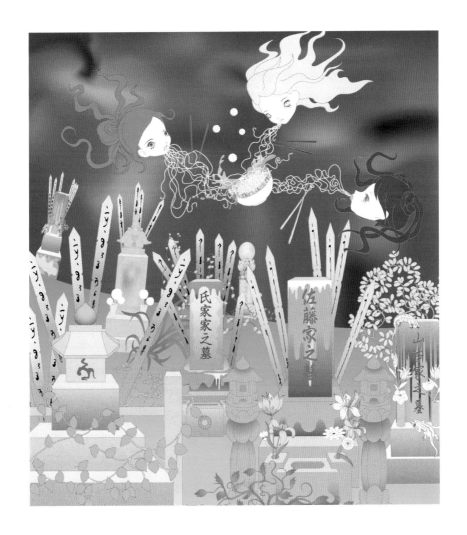

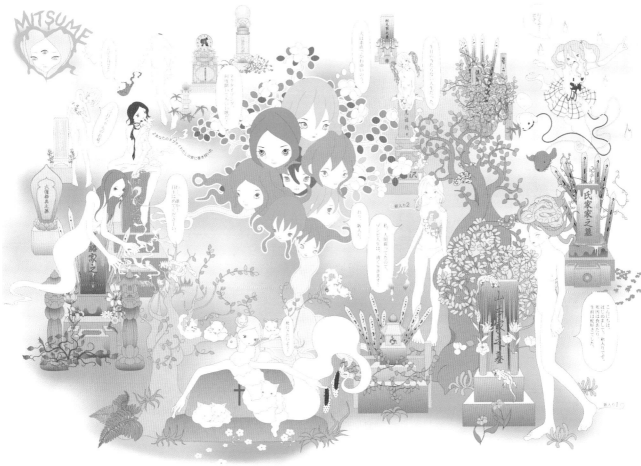

Noodle Zonmie, 2003.
Inkjet print on paper. 93 × 50.3 cm.

ラーメンゾンビ

Zombies in the Graveyard, 2001.
Inkjet print on paper. 102 × 140.9 cm. Courtesy of Emmanuel Perrotin Gallery.

墓ゾンビ

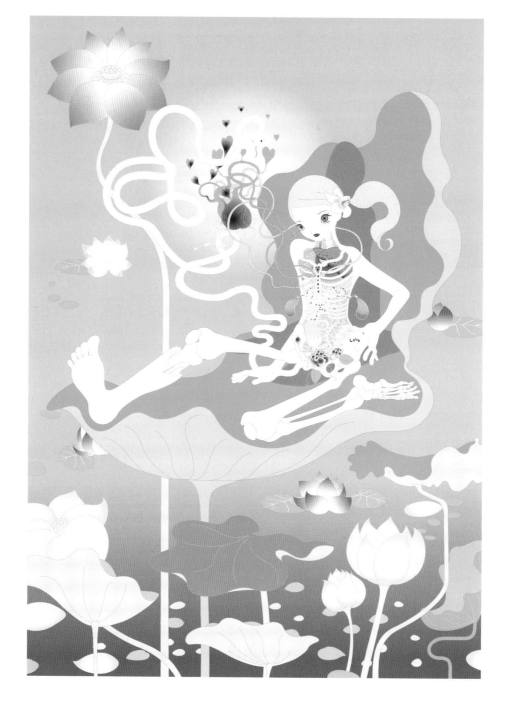

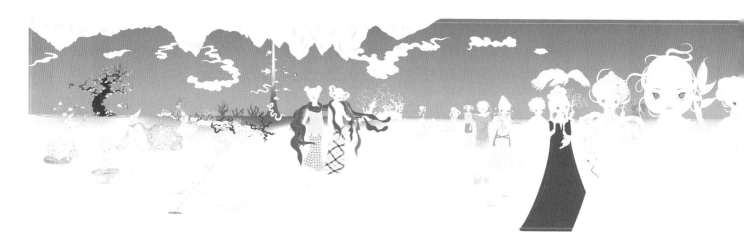

Ero Pop, 2001.
Inkjet print on paper. 143.5 × 102 cm. Courtesy of Emmanuel Perrotin Gallery.

エロポップ

The Red-Eyed Tribe, 2001.
Inkjet print on paper. 255.3 × 1598 cm. Installation at Issey Miyake, Aoyama Boutique,
2001 Spring and Summer Collection. Courtesy of Blum & Poe Gallery.

赤目族

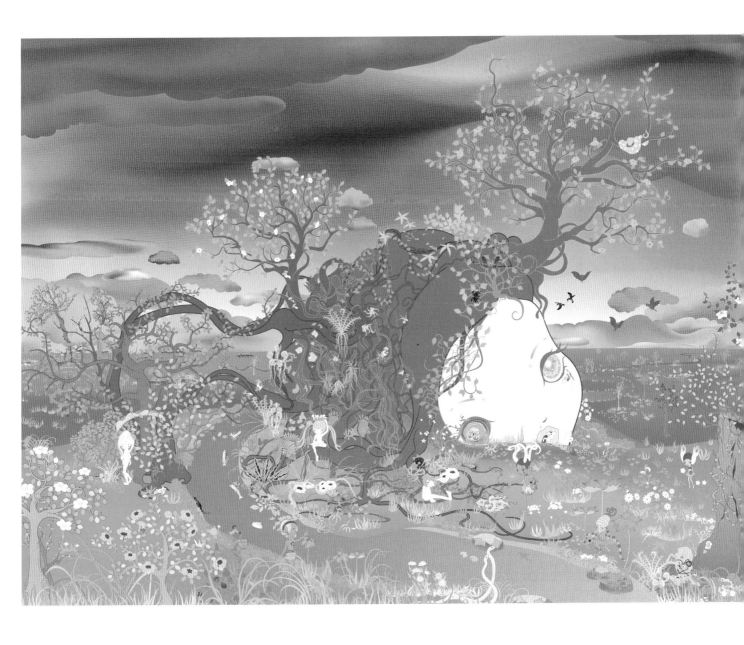

Pages 39-41: *Twilight Haruna*, 2004.
Inkjet print on paper. 360.2 × 808.6 cm.

いいこ

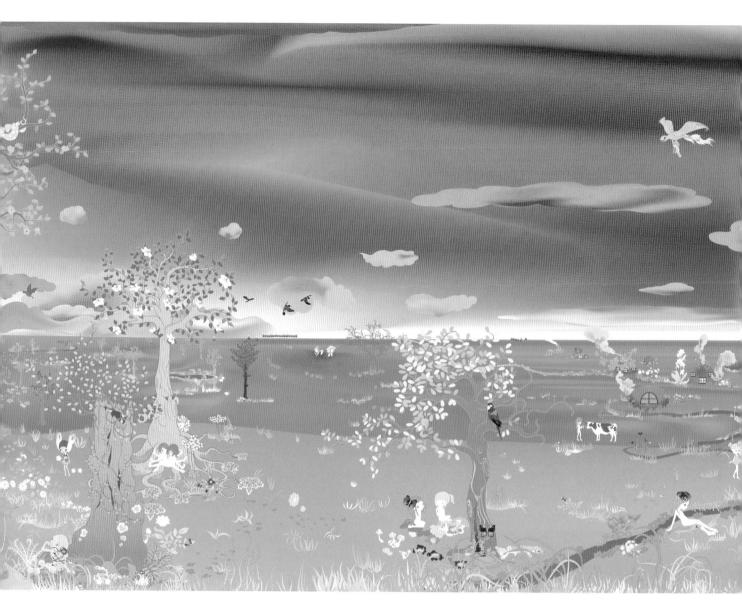

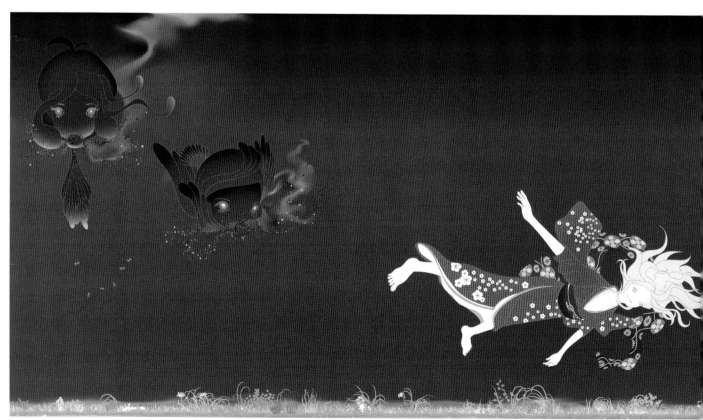

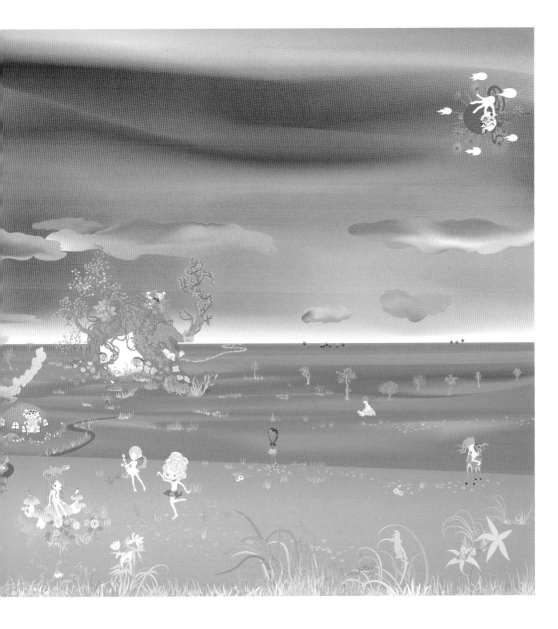

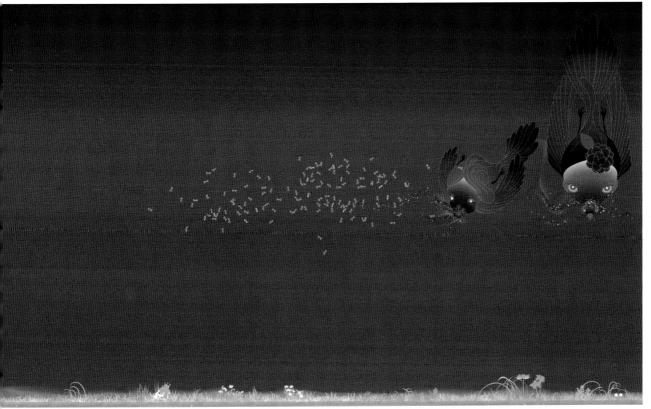

Mujina, 2002.
Inkjet print on paper. 632 × 2938.7 cm (detail).　　むじな

Top: *Window*, 1999.

Inkjet print on paper. 55.4 × 74 cm.

Courtesy of Emmanuel Perrotin Gallery.

Center, left: *Sadako*, 1999.

Inkjet print on paper. 55.4 × 74 cm.

Courtesy of Emmanuel Perrotin Gallery.

Center, right: *Gomi*, 2003.

Inkjet print on paper. 53.5 × 72 cm

Bottom: *Karin*, 2003.

Inkjet print on paper. 85 × 96.3 cm.

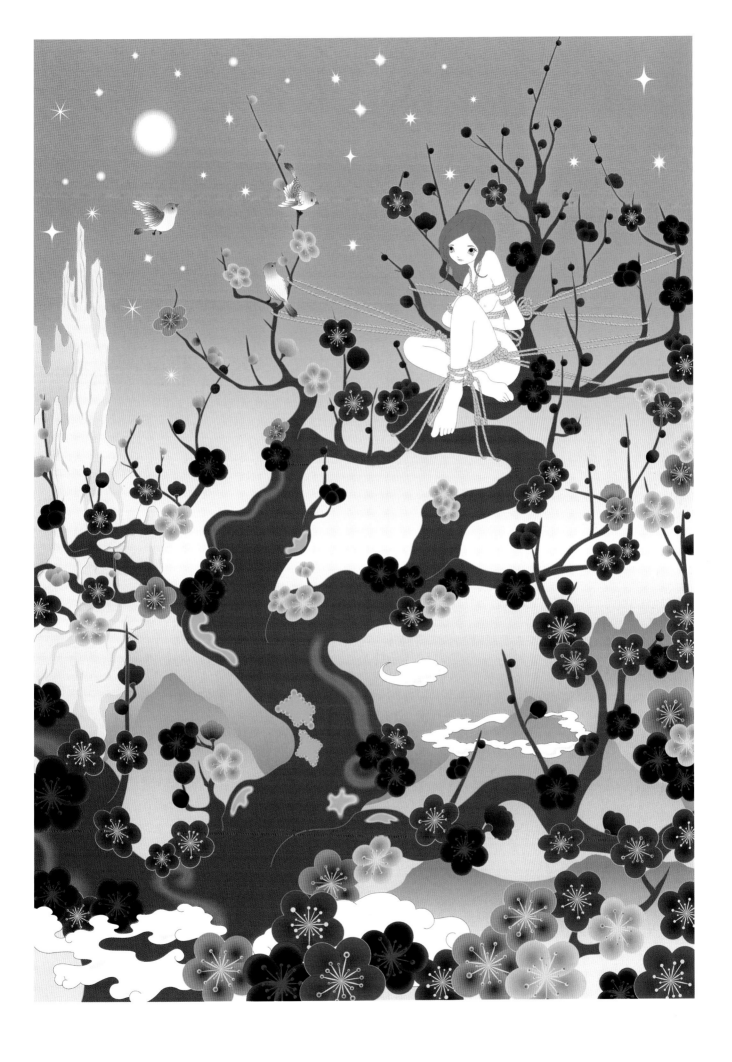

Japanese Apricot 2, 2000.
Inkjet print on paper. 104.9 × 74.9 cm.

梅 2

43

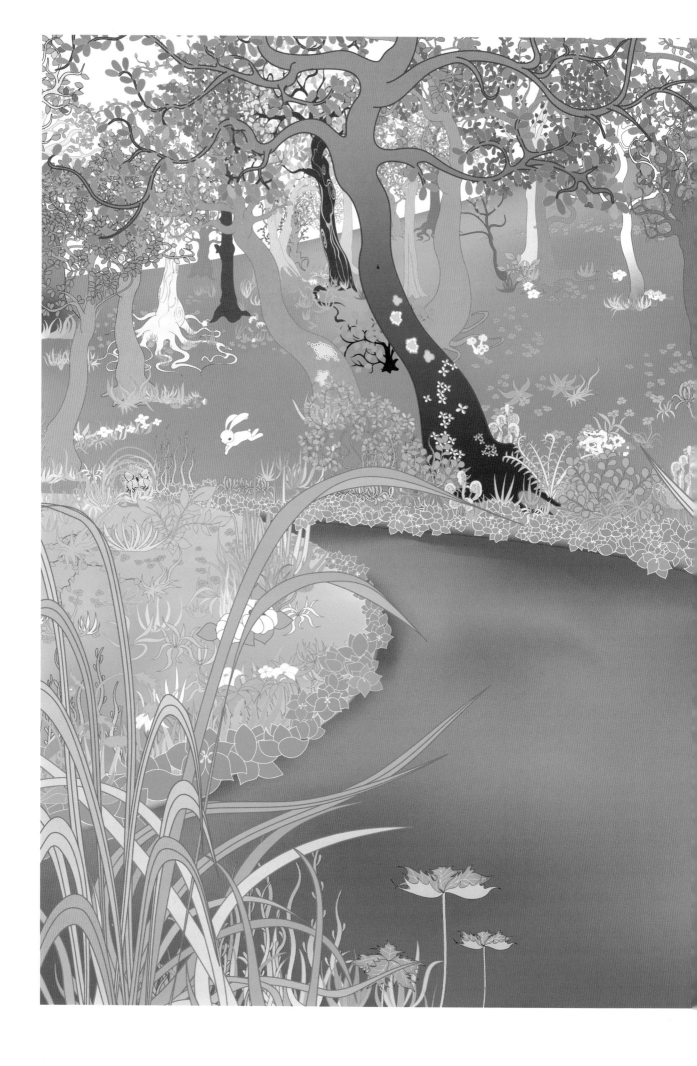

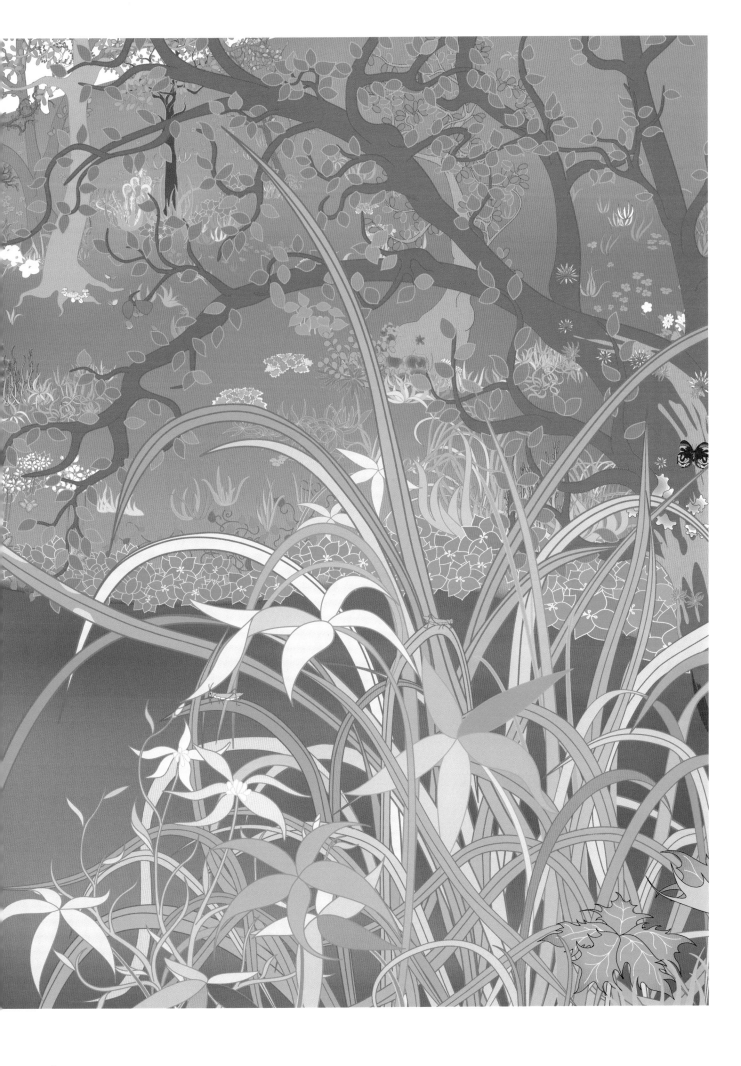

Forest, 2004.
Inkjet on paper. 162 × 130.5 cm.

Yuko Murata

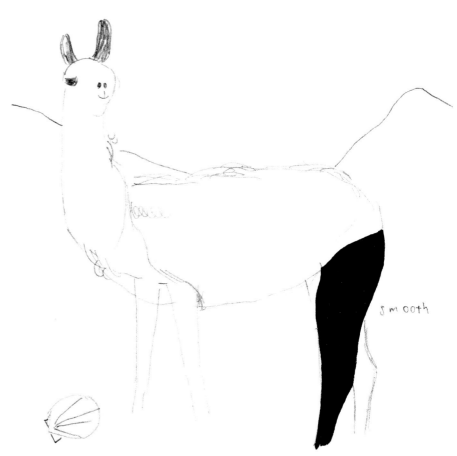

LIKE MANY OF THE artists in this book, Yuko Murata lives in Tokyo. We had our first meeting at the gallery that represents her work. It lies in the congested neighborhood of Akasaka—an amorphous sprawl of office buildings bisected by a suspended highway. But Murata's art looks elsewhere. Her preferred subjects are faraway scenes: a stalactite hanging from the roof of a cave, an underwater volcano in Iceland, or a koala in the Australian outback. Each of her paintings is based on an "original": an illustration found in an encyclopedia or, more often,

photographs she sees in travel brochures. Such brochures, and their enticements to adventure, serenity, and escape from everyday life, are ubiquitous in Tokyo—most large metro stations are banked with kiosks full of them. The ideal, they seem to say, is elsewhere. Over *there*. Why consistently choose such distant subjects? "I mostly want to paint places I haven't been to," says Murata, "because I want to draw what I cannot imagine myself." Indeed, Tokyo can be unrelenting in its relative lack of green spaces and nature. It is easy to spot photographs of nature, though, posted on

construction-site barricades and commonly lining sidewalks that run along highways.

Murata's landscapes are idyllic, pristine, and untouched by human hand—like the travel-brochure image of a perfect waterfall. Such vistas of perfection can seem unreal, and her treatment of her subjects underscores this. But instead of being off-putting in their artificiality, her reworked views of nature are oddly appealing. The soft, melting shapes and blocks of color that Murata uses to give form to her subjects are part and parcel of a general sense of warmth in the work. Natural forms are rendered like plush toys. Her animals are also cute—not "wild beasts" so much as adorable pets: a mature elk stares out beatifically; the tip of a whale's tail is beaded with pearls. Murata takes this idea yet further, attributing human emotions and qualities to animals, such as love, deceitfulness, or fear.

The human imagination has an extraordinary propensity to conjure an imaginary version of the real, believable enough to elicit true emotion, or at least sentiment. Eugène Atget made his living by selling photographs

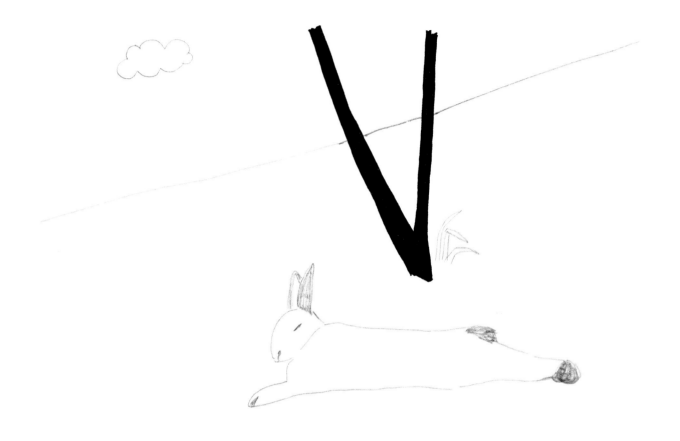

of "old Paris" as studies to artists, and one imagines that Murata would have been among those artists. Like Atget's views of Paris, which stir feelings of nostalgia even for people who have never known Paris, old or new, Murata's paintings bring us to a moment in which our collective imagination longs for something that can never quite be realized. And this seems to be her intention: the disjunction between the timeless image of a waterfall, for example, and the commuters' metro station where the picture is found in a travel brochure, stirs up a certain emotional longing.

The "cute" in Murata's work is removed from abstraction and given the spin of reality, but it is only a partial reality, as though her creatures and landscapes are caught between zones. The viewer's emotional response when looking at such work is not entirely unfamiliar: Tokyo itself may also be seen as a sort of intermediate zone, situated between the artificial flora below and the expressway overhead.

Poker Face, 2002.
Water-soluble oil on paper. 41.5 × 39.5 cm.

Poker face

Sleeping, 2003.
Water-soluble oil on canvas. 24 × 28 cm.

Opposite: *Summer Time*, 2003.
Water-soluble oil on canvas. 53 × 32 cm.

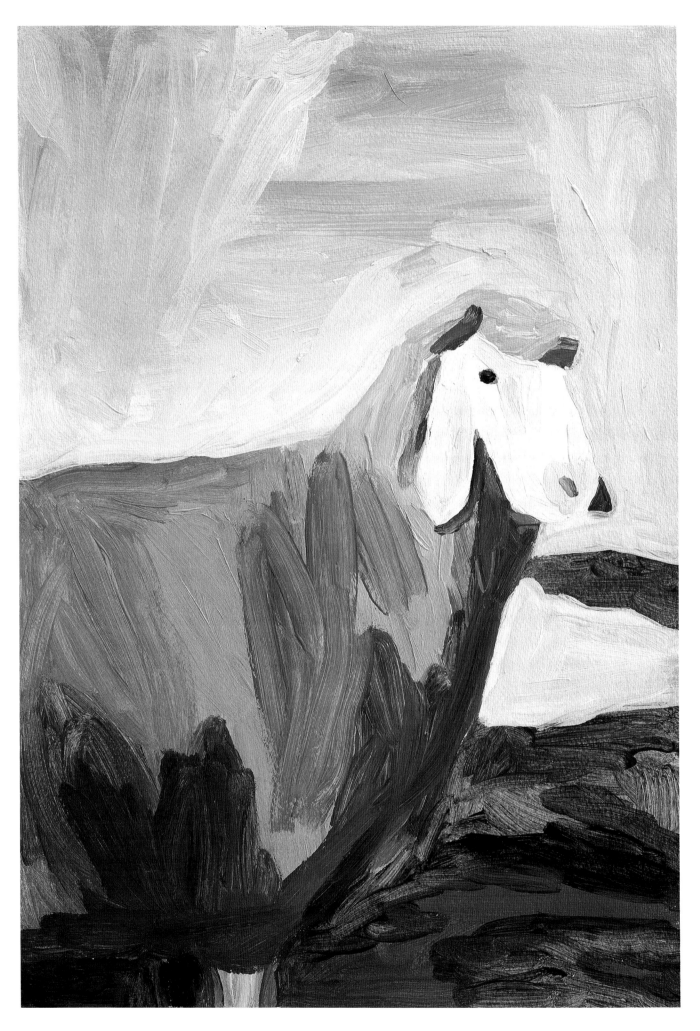

大人の羊

Grown-up Sheep, 2002.
Water-soluble oil on paper. 49 × 37 cm.

Mushroom Rock, 2003.
Water-soluble oil on LP jacket. 31.5 × 31.5 cm.

53

mushroom rock

Slope, 2001.
Water–soluble oil and oil on paper. 52 × 45.3 cm.
Collection of Mitsunobu Kumakura.

Opposite: *Ice Wall*, 2003.
Water–soluble oil on canvas. 51 × 30 cm.

slope

Ice wall

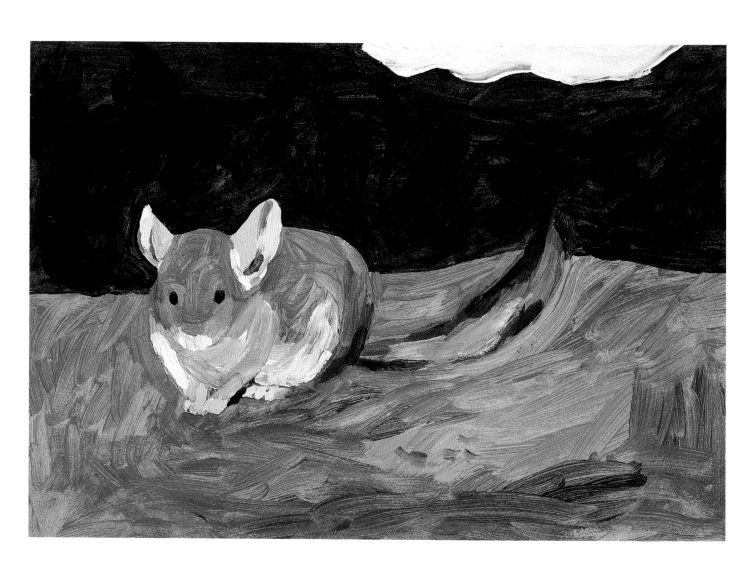

Adolescence, 2002.
Water-soluble oil on paper. 27.5 × 39.5 cm.

思春期

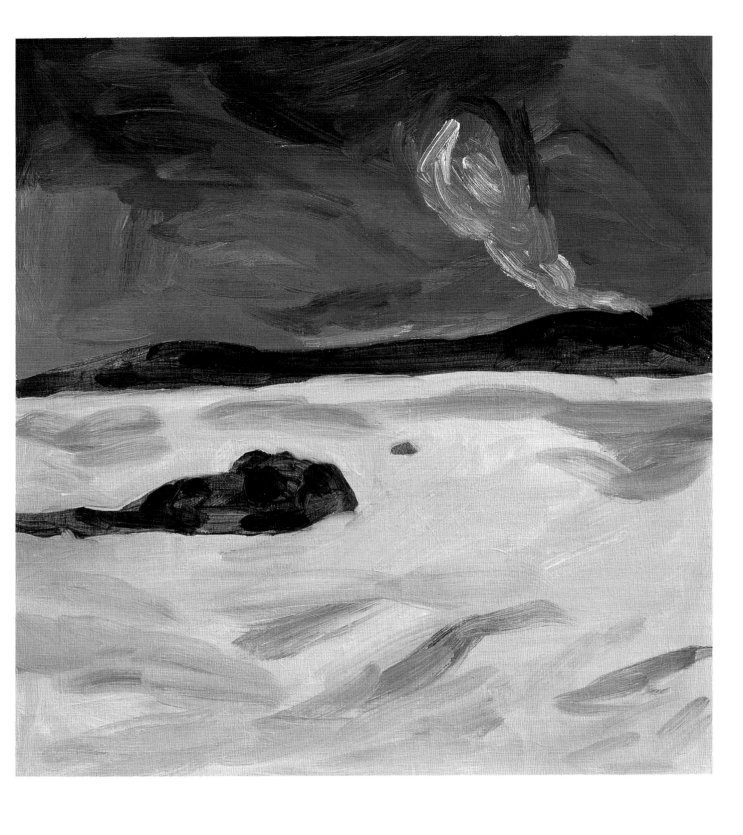

Iceland

Iceland, 2003.
Water-soluble oil on canvas. 38.7 × 37.9 cm.

57

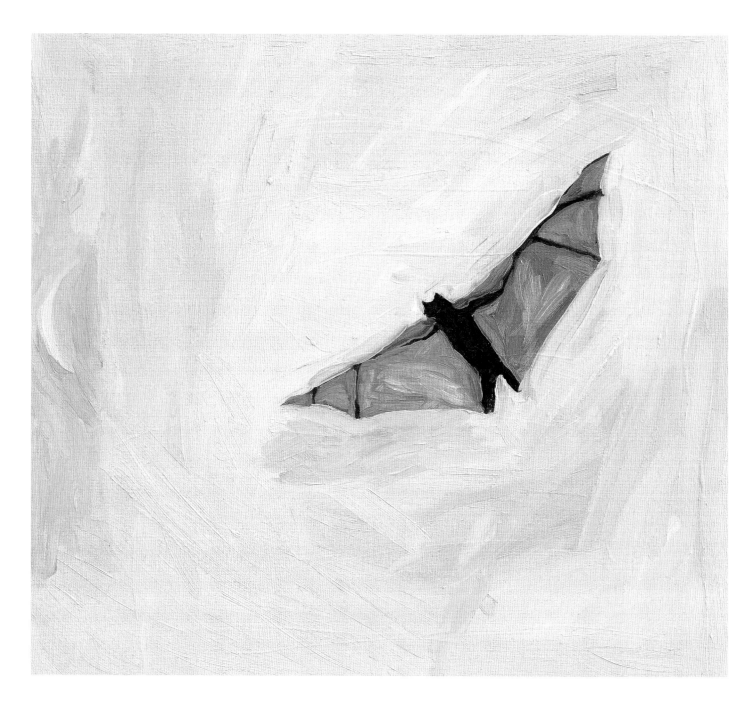

Crescent moon

Crescent Moon, 2002.
Oil on canvas. 38 × 42.5 cm.

Opposite: *Arizona*, 2002.
Oil on canvas. 47 × 26.5 cm.

アリゾナ

58

Ryoko Aoki

青木陵子

ON THE DAY I met with Ryoko Aoki, at her dealer's Osaka office, there was a band there (Aoki's friends) rehearsing for a performance. After the din had quieted down, we spent the next several hours looking through her drawings and photographs of her objects and installations, covering several years of her creative output. We discussed which works to reproduce in this volume and what approach to take. Most of my initial suggestions were met with a gentle but firm "Hmm," which could only be interpreted as flat rejection. After about the second hour, my grasp of the material was finally ambling along, and Aoki said with a satisfied smile, "You're slowly catching on, huh?"

Granted, it is not easy to get a quick handle on her work. Aoki works on multiple projects simultaneously and her output is best grouped not by theme or medium, but rather by period of production. Most of the images appearing on these pages are from late 2003 to early 2004. Though the individual segments of her work suggest narratives, especially pieces with titles like *A Person to Meet in the New Year*, Aoki maintains that there are no stories beyond simple explanations of how she made the work. She says of her emblematic drawings of wild flora: "I squat down and stare closely at a small scene of some greenery. I follow the forms and mark down what I've seen. If there happens to be a

Pages 60–62: *Pattern (Animals)*, 2004.
Ink on paper. Set of five drawings 52.4 × 34.5 cm and four 35.1 × 25 cm each.

stone beside the blade of grass, the stone gets drawn as well." Her work rewards the viewer's close attention to details, in their great numbers and their accumulated mass of intensity. "One blade of grass juts up in front of another blade, but then is behind another and bends this way and that, before and behind other elements. I look at it from up close and trace its forms like a machine." Her drawings of nature are like the ordered chaos of fractals; to zoom in on them reveals infinite levels of complexity and detailed forms within forms.

When Aoki's subject matter is animal, however, her approach changes, and we see the separation of elements and the introduction of compositional devices such as pattern. "The kinds of animals I draw are like the decorative embellishments on clothing. They're dead, in a way. The people I draw are dead too. They are merely illustrations. But nature is something else." She raises her hand and rests it on the bark of an imaginary tree. "Something that you can touch with your hands leaves an impression. Subdued nature is wild." We see this sense of the large contained within the small, as well as Aoki's recurring synthesis of the female form and nature, in the woman's seashore neckline in *The sea gets rough and there are no shadows*. The technique Aoki used to draw the monkey-shaped

charm on the woman's necklace has become part of her repertoire. Blending carpenter's glue with a black pigment, she loads the mixture into a tube and pierces the tip, so that it can be controlled like a pen. Aoki calls such drawings "Gluesights" (also see pages 64 and 68). Once the glue has partially hardened, the separate elements—still somewhat pliable—can be moved. "I'm not too good with composition, so using glue allows me to move things around on the sheet after they've been drawn."

Aoki makes books, papier-mâché and clay sculptures, stenciled cutouts, animations (in collaboration with her husband, the artist Zon Ito), stuffed dolls, and installations.

But how does this all fit in with the detailed drawings of nature, or rambling compositions like *Radio Wave Observation*, or the simple sketch of *Smoked*? Perhaps the experience of Aoki's work is best understood through the accumulation of details as observed from moment to moment. Rather than presenting something comprehensive, it functions within its own context and self-referential logic, like the rambling line segments in *Stream 1*: interlacing details, individual folds and ripples—like the petals of a rose—are nested with an intricate complexity.

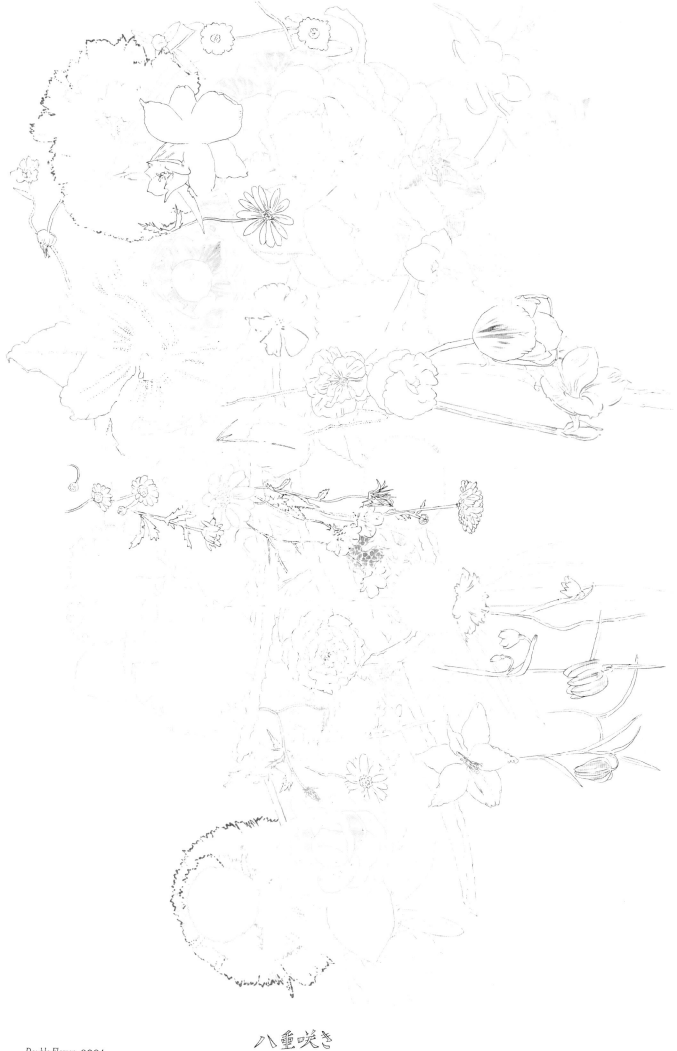

八重咲き

Double Flower, 2004.
Ink, felt-tip pen, and watercolor on paper. 52.4 × 36.5 cm.

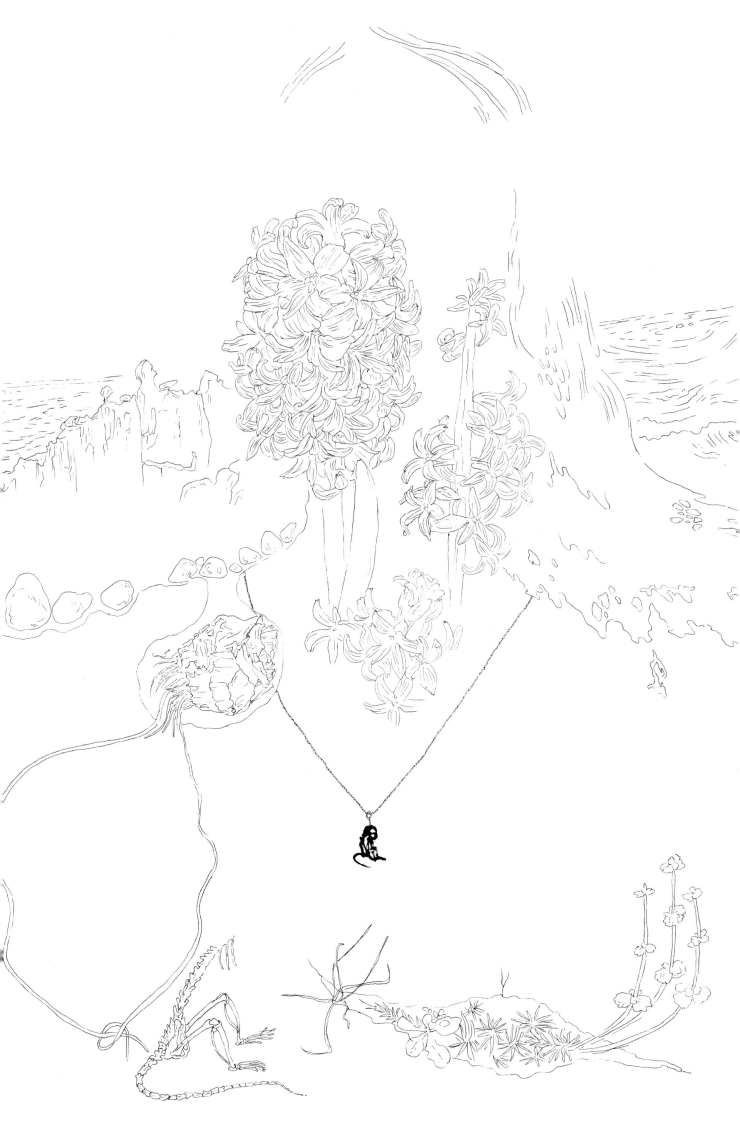

Opposite: *The sea gets rough and there is no shadow*, 2002.
Ink and wood glue on paper. 40.2 × 29.7 cm.　　海はあれものかげもなし

Sliding Circle, 2004.
Ink and felt-tip pen on paper. Diptych: 17.5 × 13.4 cm each.

Bodhisattva, 2004.
Ink and felt-tip pen on paper. Diptych: 29.7 × 21 cm each.　　菩薩

65

Opposite: *Futon (M)*, 2004.
Ink and felt-tip pen on paper. 25 × 25 cm.

布団S

Futon (L), 2004.
Ink and felt-tip pen on paper. 52.4 × 36.5 cm.

布団L

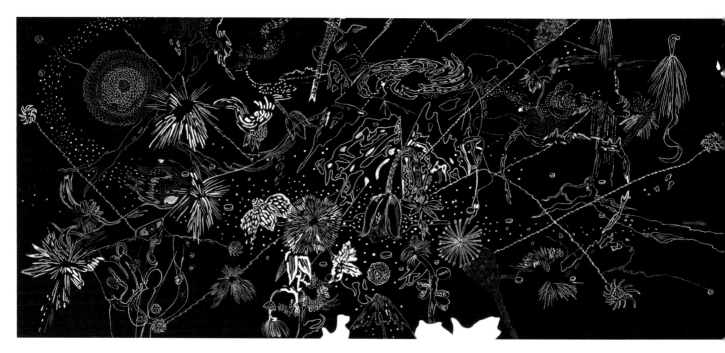

電波観測

燻製

Top: *Radio Wave Observation*, 2004.
Ink and watercolor on paper. 24 × 54.1 cm.

Center left: *Baked Roll*, 2004.
Felt-tip pen on paper. 29.7 × 21 cm.

Center right: *Peeling Off*, 2003.
Colored woodwork glue mixed with acrylic on paper. 14.8 × 10.5 cm.

Bottom, left: *Smoked*, 2004.
Ink on paper. 17.5 × 13.4 cm.

Bottom, right: *Water Passage*, 2004.
Ink on paper. 17.5 × 13.4 cm.

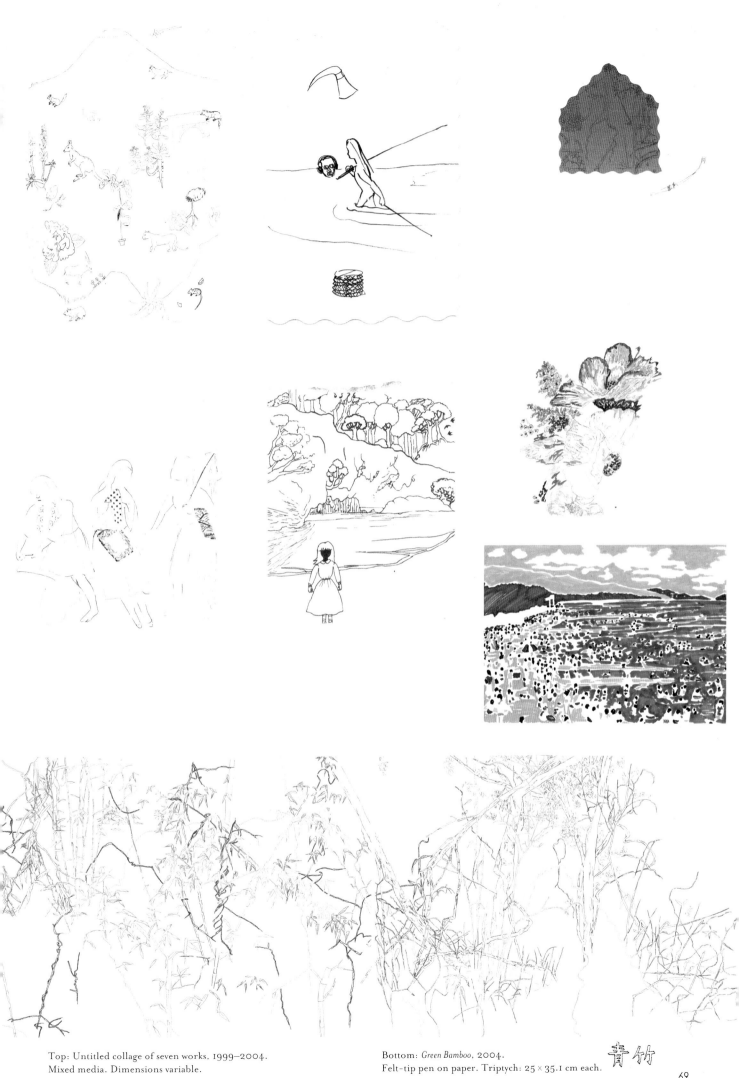

Top: Untitled collage of seven works, 1999–2004.
Mixed media. Dimensions variable.

Bottom: *Green Bamboo*, 2004.
Felt-tip pen on paper. Triptych: 25 × 35.1 cm each.

青竹

69

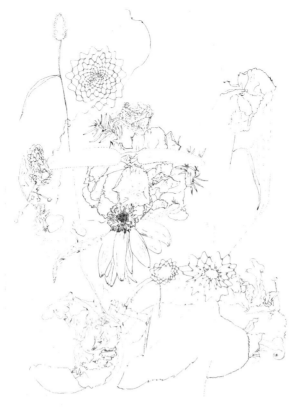

Pages 70–71, Top: *Untitled collage of five works*, 2003–2004.
Mixed media. Dimensions variable.

Bottom: *From the tip of the head*, 2004.
Ink on paper, collage. 29.2 × 41 cm.

頭のてっぺんから

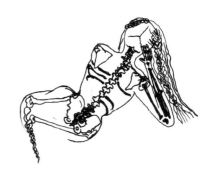

近目

Bottom, left: *Near Sight*, 1998.
Ink on paper. 29.7 × 21 cm.

Bottom, right: *Stream 1*, 1998.
Laser output on paper. 27.9 × 20.3 cm.

流れ1

一つ目

One-Eyed, 2004.
Ink and felt-tip on paper. Triptych: 10 × 10.6 cm, 14.8 × 10.5 cm, 10 × 10.6 cm.

Opposite: *Lily*, 2003.
Ink on paper. 35.2 × 25.1 cm.

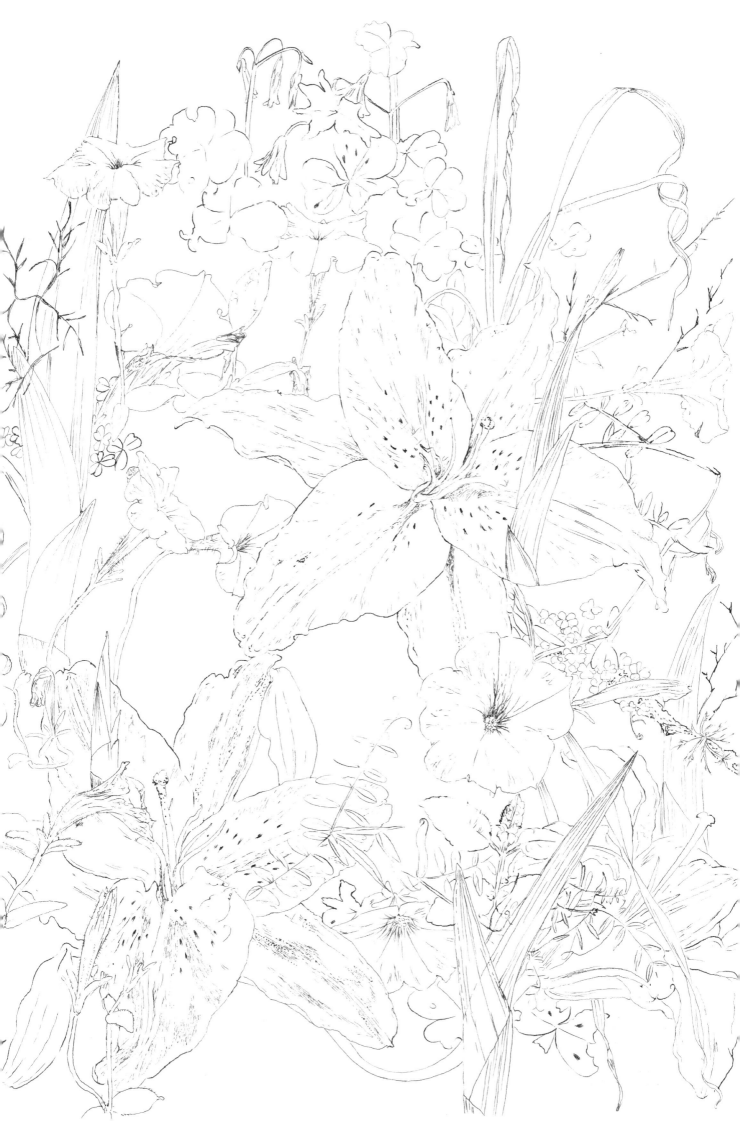

Yuiko Hosoya

Before Yuiko Hosoya and I began talking about her work (our chat took place over plates of French fries and bowls of soup in a *fami-resu*, or greasy spoon, in Meguro), I asked what "cute" means to her. After a few moments' thought, she said, "A slightly pudgy belly that sticks out over the belt just a little; now that's cute!" Indeed, this taste for subtle warping runs through her work. In Hosoya's series "Lymph: The Small Creatures," she has drawn (then sewn) hundreds upon hundreds of playfully proportioned animals—all inhabitants of the imaginary land of "Lympah." With its ever-growing population, Lympah fulfills a simple purpose for the artist: it is an idyllic place of joy and warmth. For this book, Hosoya has created a piece called *Swi-kin-chick-a-mok*, for which she embroidered a number of her Lympah creatures onto a girl's skirt.

Hosoya's other favorite subject is seen in a series of portraits of girls, all of which are based on imaginary sitters. There is a palpable tension in these pictures, though the fictional sitters may affect an easy repose

(hugging their knees, looking off to one side). The sharpness of detail in these portraits can at times seem almost too intense, as with the fuzzy haze surrounding a dandelion in *Flower of my left hand*. The weight of Hosoya's lines in these drawings varies between heavy marking and subtle, attenuated penciling; but textures of skin, hair, and fabric all possess a strong linear quality, regardless of the form that she is rendering. Simple and fanciful forms further emphasize the demarcations of the various spaces of the paper. These cloudlike shapes may frame the figure,

or protrude like a feather, or peek out from behind a girl's head. Hosoya's use of graphic forms in conjunction with the portraits maintains a steady tension between verisimilitude and the element of imagination.

While Hosoya's portraits and animal-drawings are as unlike as night and day in terms of both form and subject, the graphic lines that loop around the figures do align them visually. But it is this positive/negative relationship between the two that interlinks the two worlds and enables their exchange. First, Hosoya sets up a situation in which

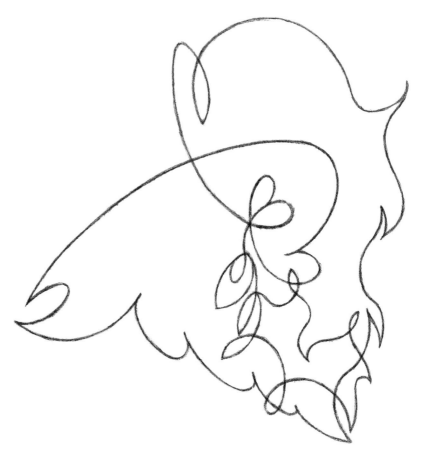

it is not entirely clear which is closer to reality: her roughly drawn animals (based on photographs, but less "realistic") or her sharply outlined portraits (taken entirely from her imagination, but more "realistic")— a paradigm similar to that in Yuko Murata's work (pages 46–59). Hosoya's animals comprise a countless array of species, while the portraits are limited in number. Each portrait is meticulously composed in its frame, whereas the animals roam "free" on the skirt. The animals are colored; the portraits monochromatic. There is also a

subtle interweaving of Hosoya's two modes, when the animals of Lympah appear as decorative elements in the portraits. While the two worlds interact in such subtle ways, Hosoya allows their respective quotients of reality to comment on one another.

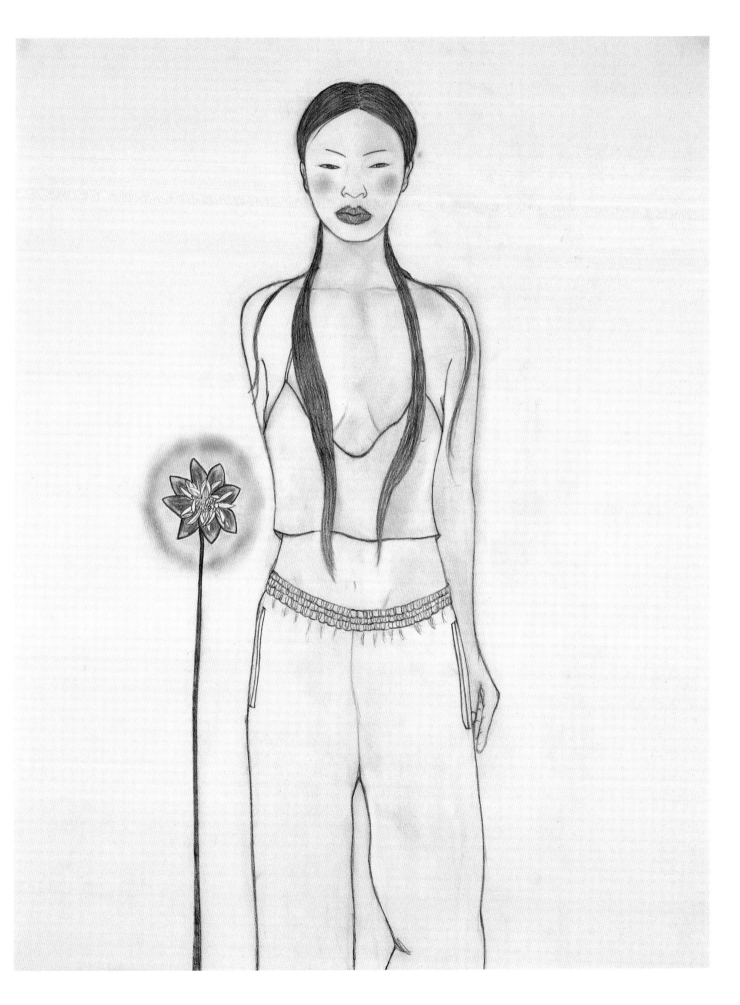

Flower of my left hand, 2001.
Pencil on paper. 65 × 50 cm.

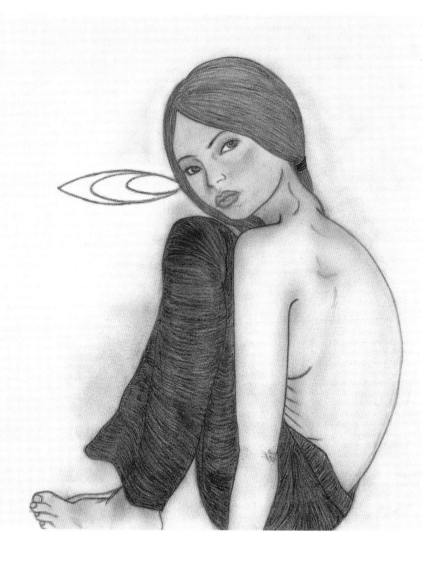

tamitami, tamitami, 2003.
Pencil on paper. 29.7 × 42 cm.

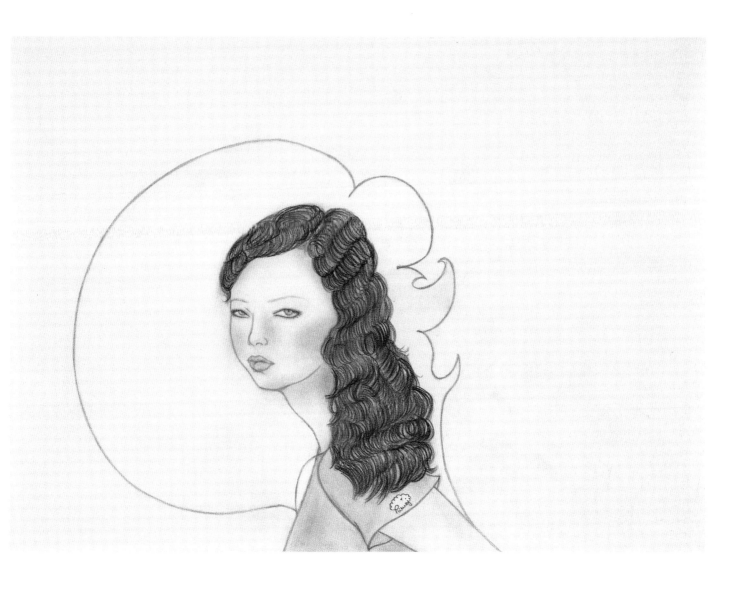

Entwined, 2003.
Pencil on paper. 29.7 × 42 cm.

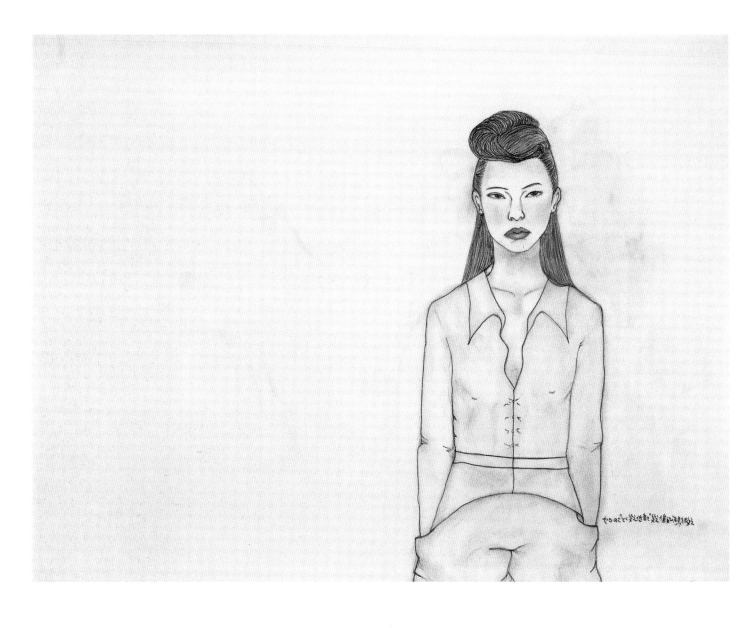

Save the moldy horse, 2002.
Pencil on paper. 50 × 65 cm.

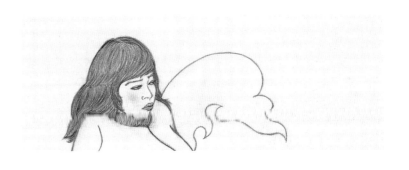

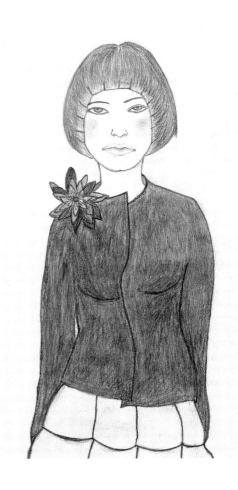

遠くとか行きた

恋まを自分に ネたる

Above: *I went somewhere far away*, 2
Pencil on paper. 13 × 37 cm.

Below: *I had to make it my treasure*, 2000.
Pencil on paper. 50 × 65 cm.

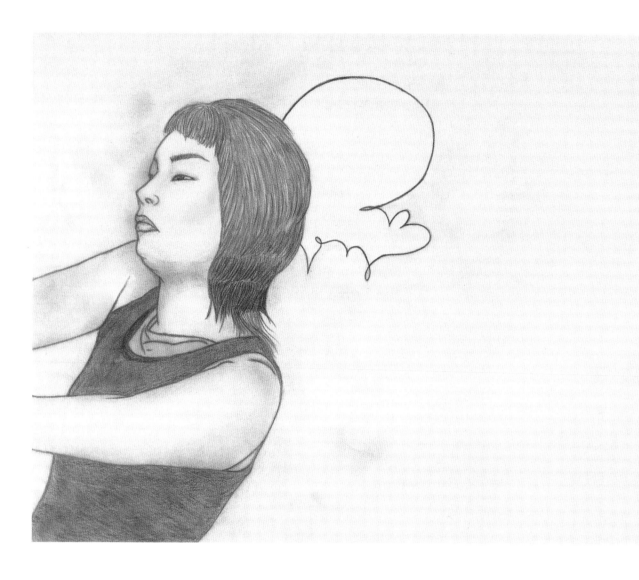

Prussian blue and sideburns, 2003.
Pencil on paper. 29.7 × 42 cm.

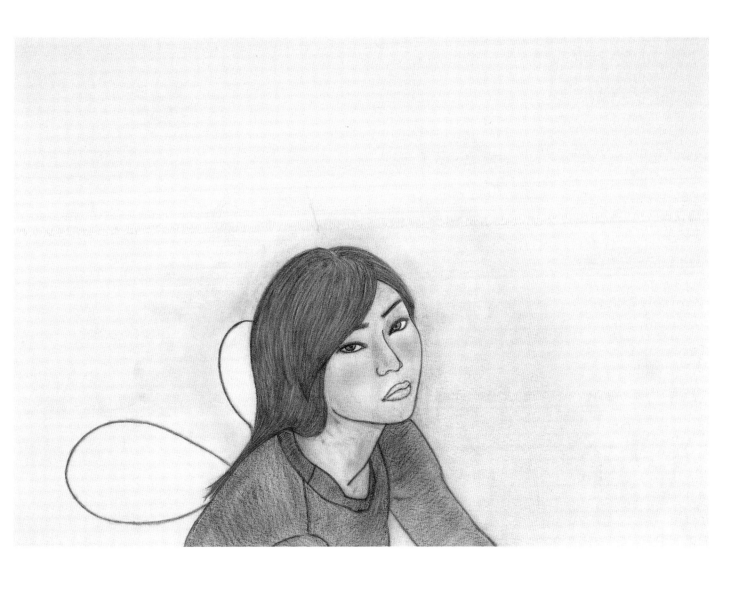

The one under your eyebrow, 2003.
Pencil on paper. 29.7 × 42 cm.

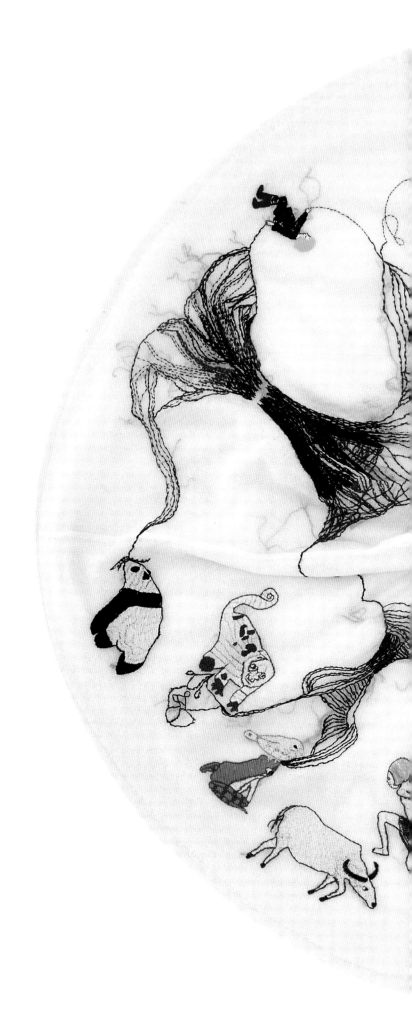

Swi-kin-chick-a-mok, 2004.
Gauze and thread. 140 × 104 cm.
Skirt made by Rie Yanai.

84

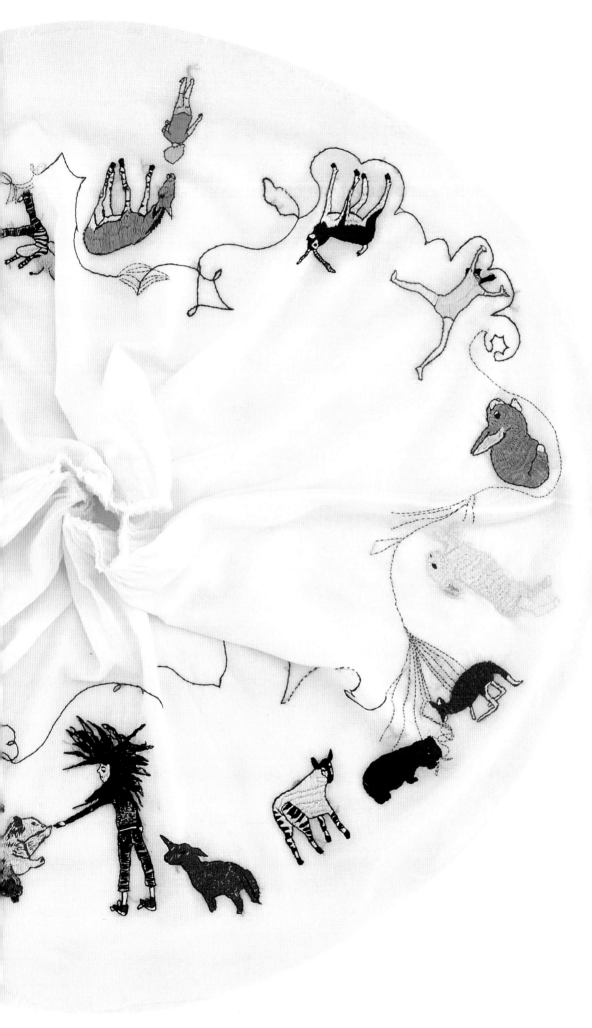

how's that baby doing, 2002.
Pencil on paper. 30 × 30 cm.

*I heard a strange bird singing in my garden when I ran out to see it there was
only a Japanese woman whistling who always talks to herself*, 2002.
Pencil on paper. 30 × 30 cm.

Aya Takano

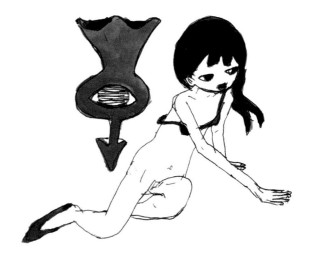

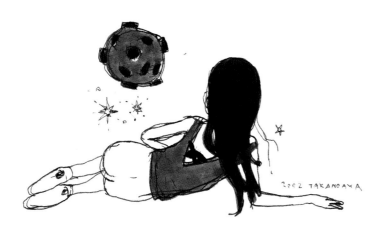

WITH ITS VAST, OPEN-AIR atrium, traversed by metal walkways and enclosed by a high glass roof, the Kyoto train station looks like a space station—the perfect place to discuss the work of a young artist so enthralled by science fiction. Although ultimately we found that the station was too noisy to allow us to talk—and so walked to the nearby, seventeenth-century Higashi Honganji temple (we were in Kyoto after all)—our subject remained science fiction and the future.

Takano says, "I grew up reading Osamu Tezuka's manga *The Phoenix*. Such stories are part of my background. My father had a collection of manga that I would regularly

read, and until the age of nineteen I thought everything I read was true!" She laughs: "Until then the world was a thing of wonder and excitement for me. So now when I read SF it's in order to remember the excitement I used to feel. Even now, I sometimes think that we can fly if we just try hard enough."

Takano has also been influenced by American science fiction writers James Tiptree, Jr. and Cordwainer Smith (the pseudonyms of Alice B. Sheldon and Paul Linebarger, respectively), whose stories Takano has adapted into manga (as serialized in the periodical *SF World*). "I think the way Smith and Tiptree lived their lives was also amazing," she

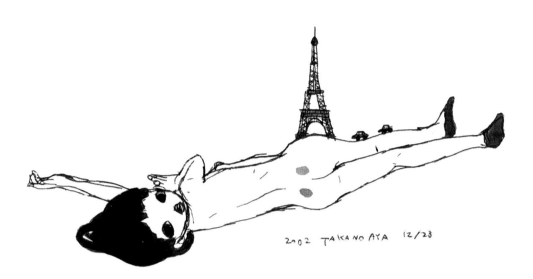

2002 TAKANO AYA 12/28

says. "Tiptree was a graphic artist and painter until she entered the Air Force Intelligence during World War II, and then served in the CIA, in photo-intelligence. Smith was a diplomat and highly respected authority on Far Eastern affairs, and served as a major in the U.S. Army. Smith kept his writing a secret until his late years, and Tiptree wrote while working on her doctoral studies." The perennial themes of these writers are common topics of science fiction in general and are also present in Takano's manga and drawings: alternate states of reality, the destruction of the natural environment, the survival of such devastation, the quagmire of human sexuality,

cultivation of technology, and the exploitation of untapped human capabilities, such as telepathy.

Although Takano's work has its thematic roots in science fiction, the sinewy nymphs and gentle acrylic washes of her work intimate other channels of stylistic inspiration. Takano notes, "Even though I am inspired by science fiction, the times when I draw best are when I draw intuitively." The fluidity of her lines and the studied exaggeration of her figures suggest both speed and absolute technical control in her working method. This approach is in keeping with the fluidity often associated with traditional Japanese art, an influence that is particularly clear in her

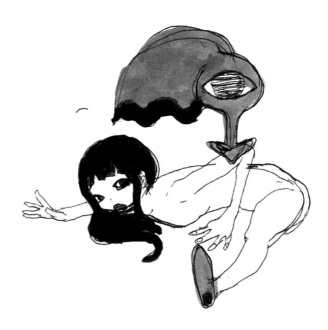

series of "Bridge" drawings. Referencing traditional Japanese art in such a manner is a process she likens to *honkadori*, a "cumulative" Japanese literary device in which a writer lifts the first line of a haiku from another writer, and then adds two original lines of his own. "When I see something cool in a great artist's work, I want to incorporate that into my own. . . ."

The erotic charge of Takano's pictures seems to be wholly unintentional. "A lot of people think that I make direct references to sex in my drawing, but that's not the case," she says. "The characters I draw just happen to be naked at times." Her figures, with their slim bodies and

bulbous heads, are indeed often nude or only partially dressed, and resemble the forms of octopus and jellyfish; their oblong eyes also resemble those of sea creatures. The broken and multiple lines of Takano's drawings suggest a sort of refraction through translucent objects undulating in water. Instead of the clear and solidly inked outlines so typical of manga, Takano's unaffected and intuitive drawings embrace the playful aesthetic of distortion, and reveal great ease and mastery of a style all her own.

Pages 91–101: *Subterraned*, 2004.
Acrylic on paper. Set of 11 drawings, 29.7 × 21 cm each.

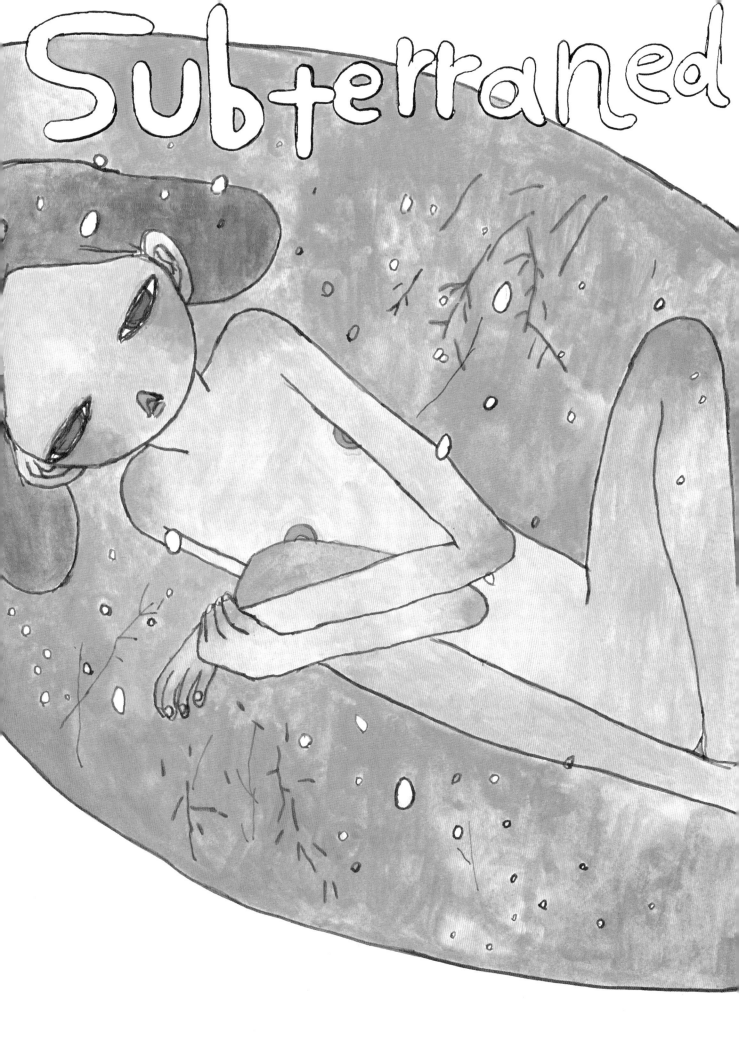

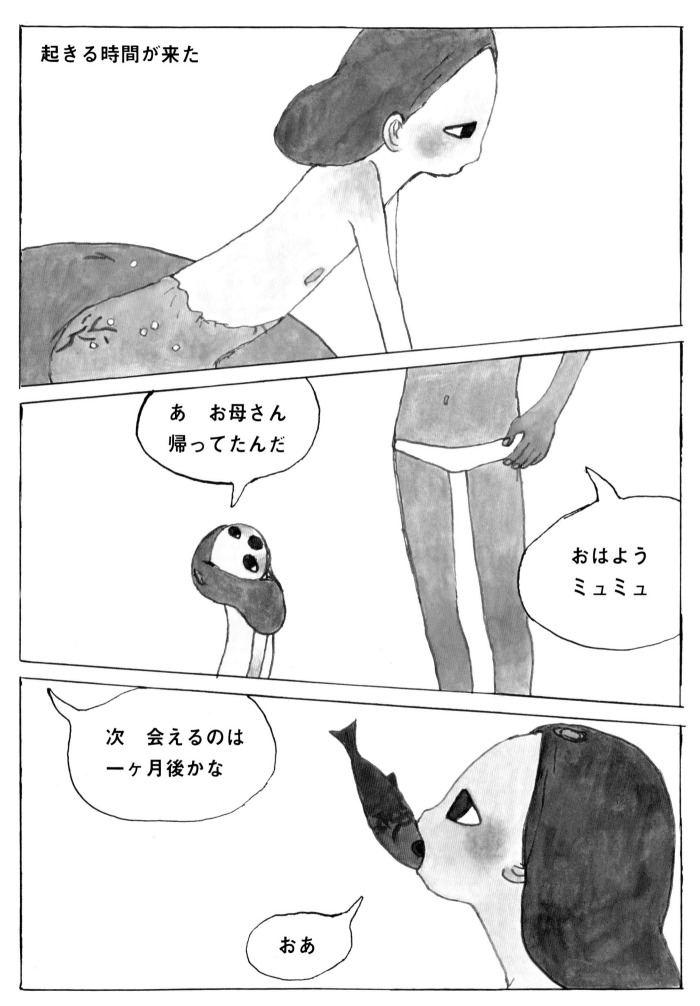

1. Time to get up. 2. "Hey, mom, you're back."; "Good morning, Myu Myu." 3. "Next time we meet will probably be a month from now." 3. "Ohh . . ."

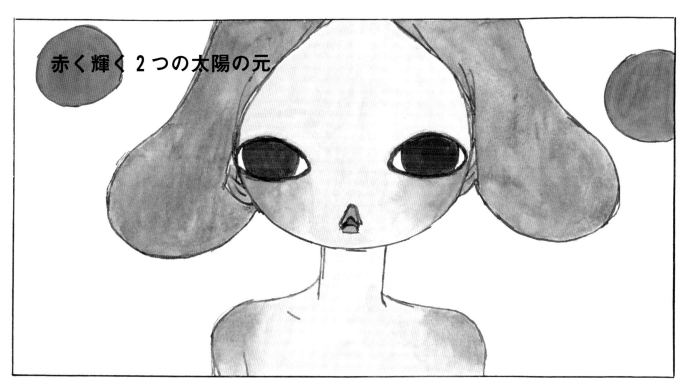

赤く輝く 2 つの太陽の元

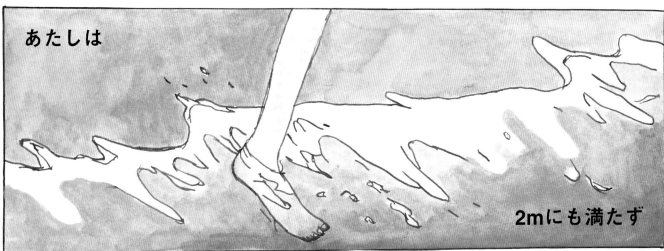

あたしは

2mにも満たず

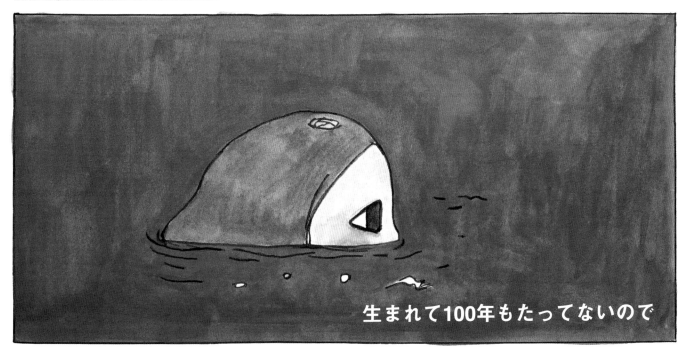

生まれて100年もたってないので

1. In a land of two suns . . . 2. I'm just under two meters tall 3. and I'm not even a 100 years old yet.

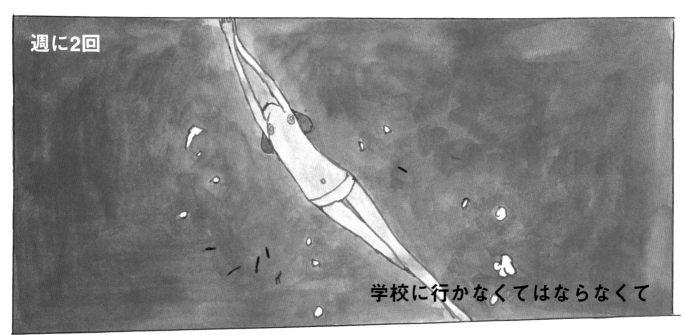

週に2回

学校に行かなくてはならなくて

お母さん‥

プ

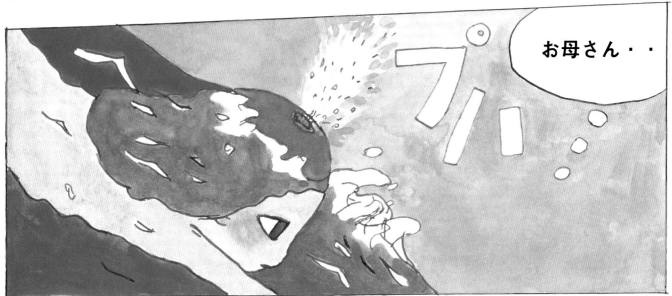

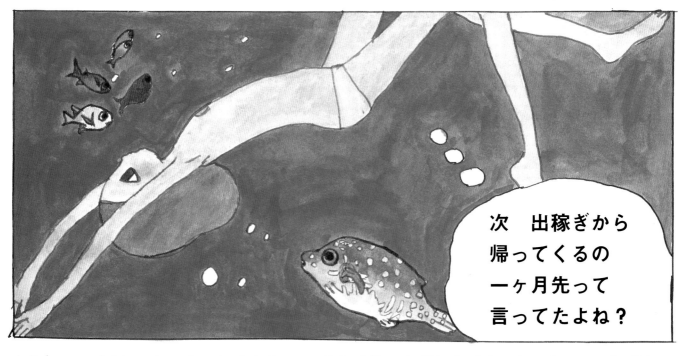

次　出稼ぎから
帰ってくるの
一ヶ月先って
言ってたよね？

1. Twice a week I have to go to school. 2. Mom . . . 3. Next time she'll be back from her migrant work will be a month from now. That's what she said, huh.

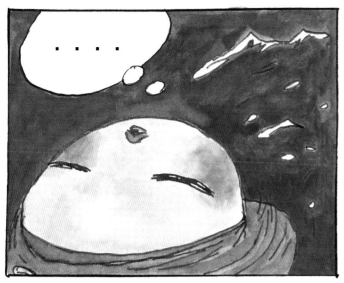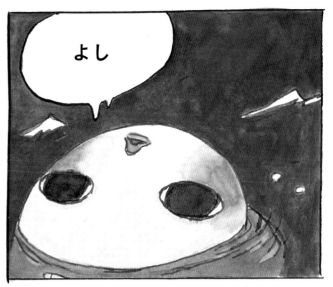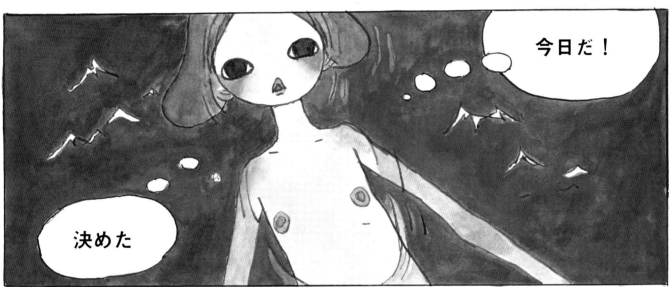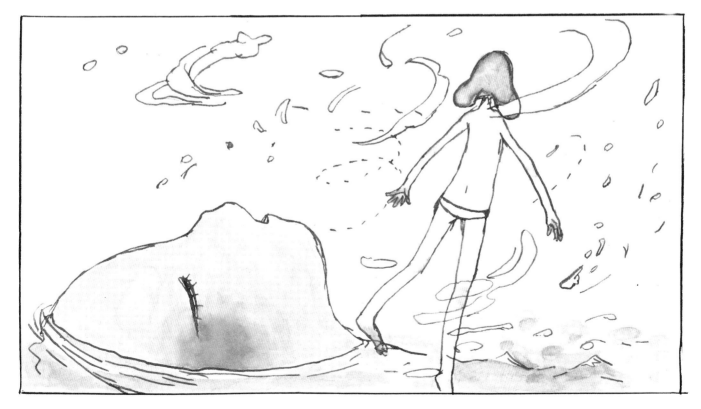

1. Hmm. . . 2. "That's it!" 3. It's decided. Today's the day.

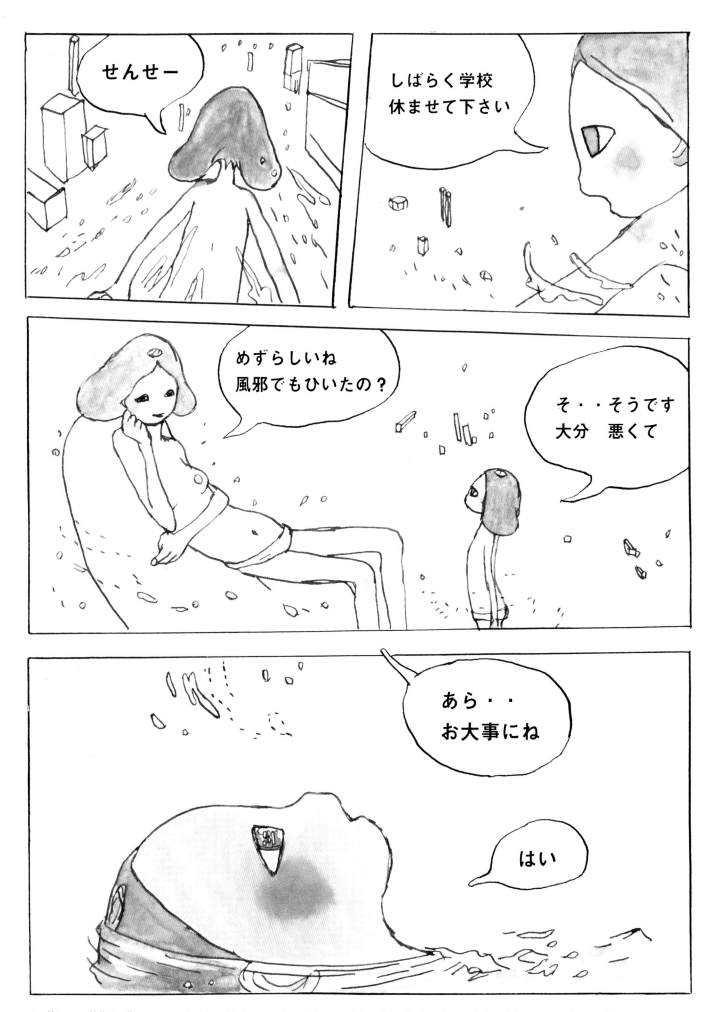

1. "Sensei!" 2. "I wanna take off from school for a while." 3. "That's weird. Did you catch a cold or something?"; "Uh, yeah, a real bad one." 4. "Oh, no. Take care."; "Okay."

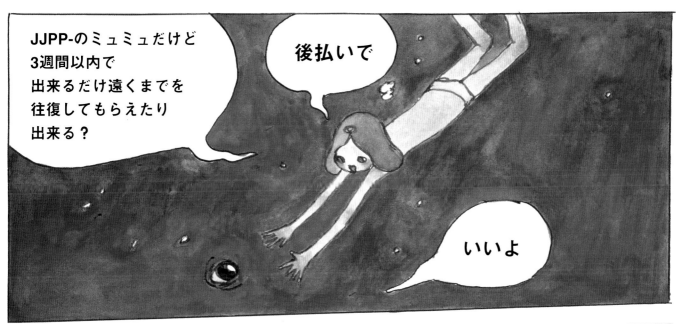

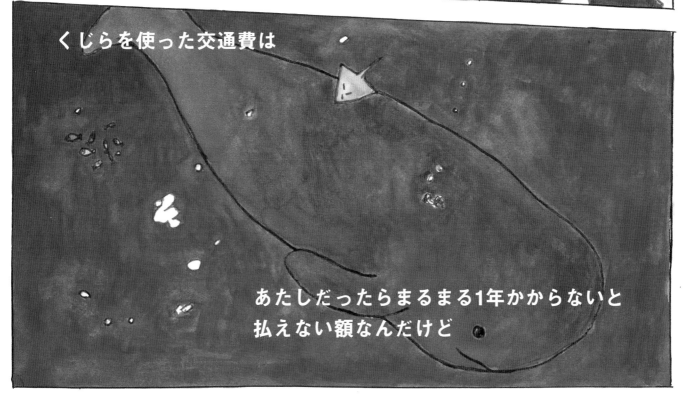

1. "This is JJPP Myu Myu. Can you take me as far as possible round-trip for 3 weeks? On credit?"; "No problem."
2. "Thanks." 3. The fare for a whale transport will take me a full year to pay off.

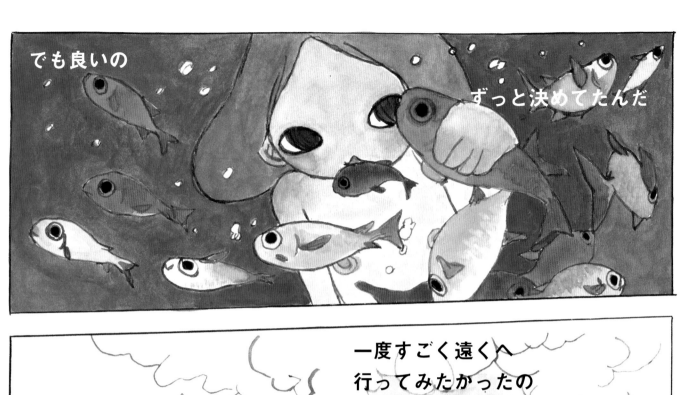

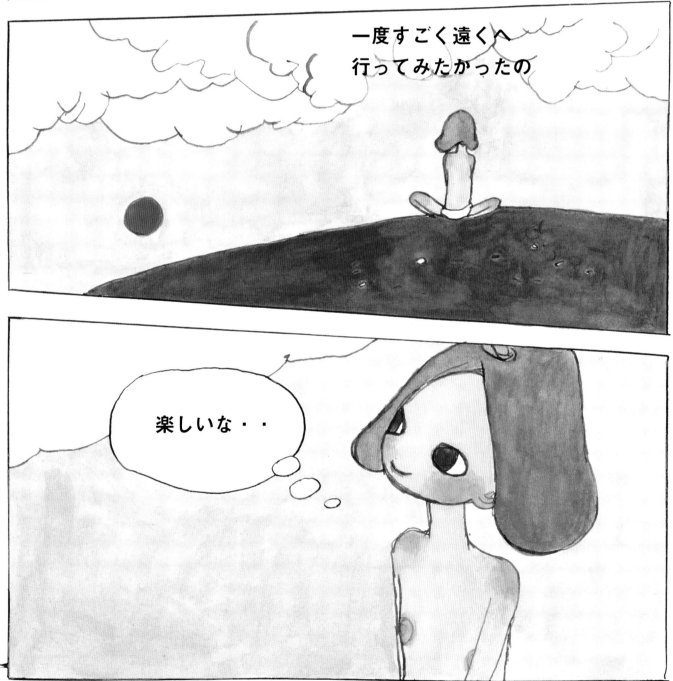

1. But that's OK. I made up my mind a long time ago. 2. For just once I want to go out really far. 3. It'll be fun.

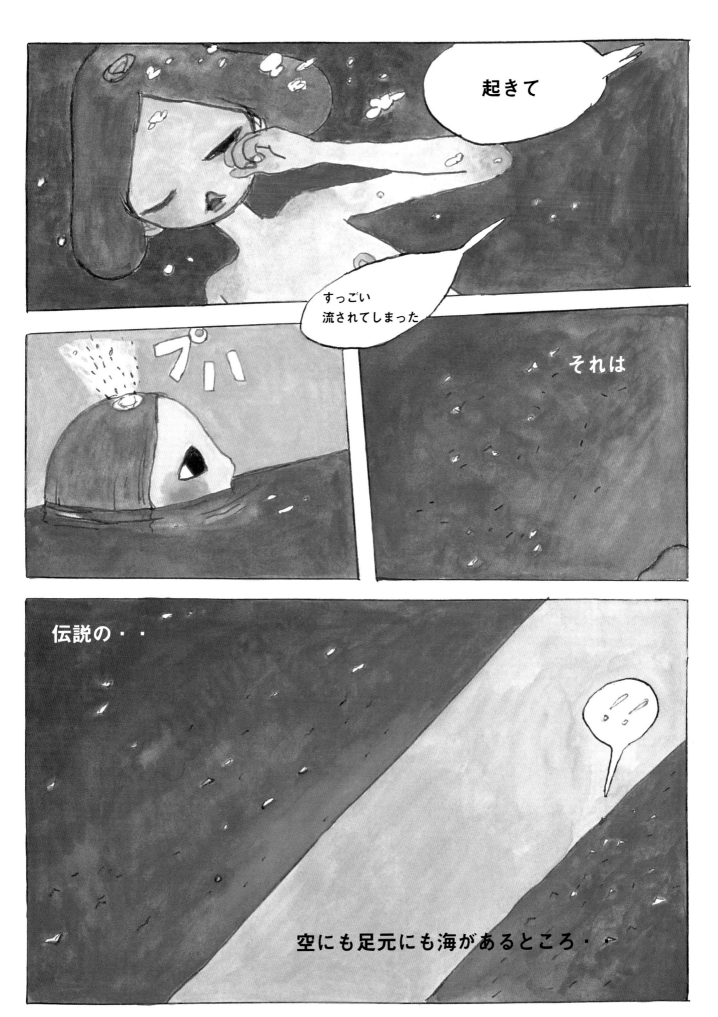

1. "Wake up! We really came out far." 2. That's the . . . 3. fabled place where there is an ocean above and below.

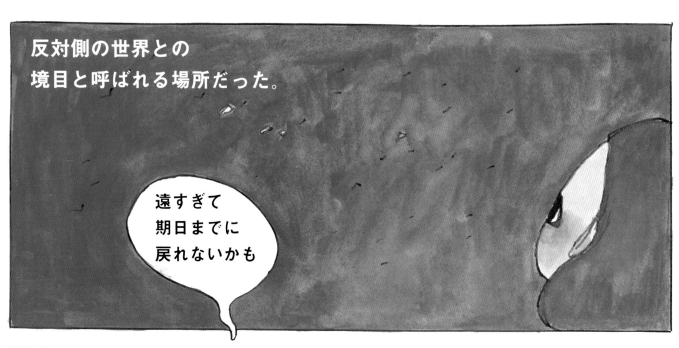

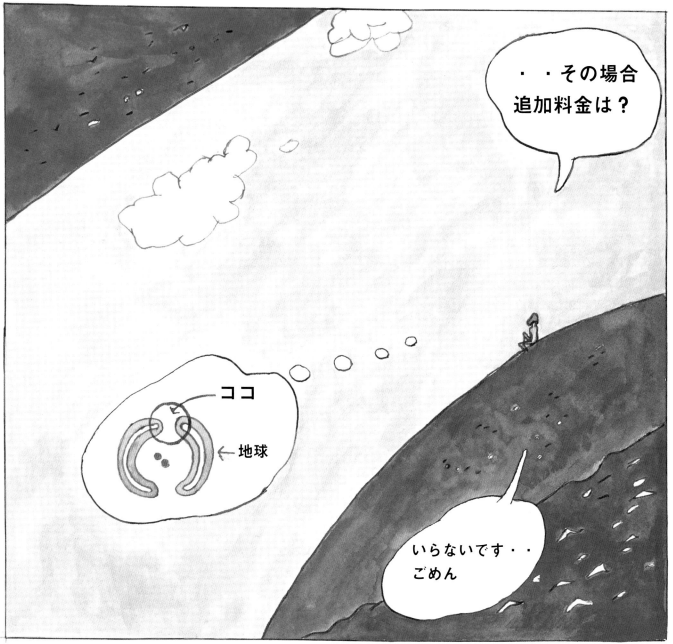

1. It's the place that divides this world from the next.; "We probably won't be able to make it back in the scheduled time." 2. "Wow! How much extra will that cost?"; "Don't worry about it." INSET MAP: You are here (top arrow); Earth (bottom arrow)

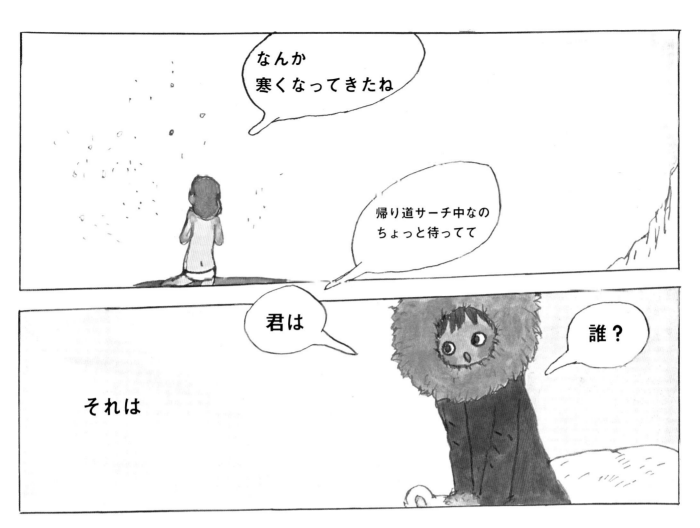

1. "It's kinda cold, huh?"; "Return route search has been activated. Give me a minute." 2. "You! Who are you?" 3. I'd find out later that seeing this boy riding a polar bear is the first encounter of Earthcore dwellers and people who live on the Earth's surface (a place called the Arctic Zone). This episode thus begins a period of a thousand years called the Golden Era.

Chinatsu Ban

WHAT COULD BE CUTER than baby elephants lapping up ice cream? Perhaps a baby elephant blowing bubbles that contain still more baby elephants? "*Zo* [elephant] written phonetically is an important image for me," says Chinatsu Ban. "So is the nose. It's so long, and I'm really drawn in by the shape." She clarifies what may already be fairly evident: "It's really sexual, actually." In *HAPPY BIRTHDAY*, a large elephant perched atop an apple core blows out the candles on a cake. The gust of wind from his trunk lifts up a girl's skirt and gives an ebullient, smaller elephant a peek up her dress. Even baby elephants, it seems, have sexual impulses. And so do little girls, as shown in *Twin Mt. Fuji*. Ice cream, underwear, and dung are also favorite subjects for Ban. In Japanese, underpants are called simply "pants," so the elephant character that appears throughout the paintings wearing them is naturally called "Zopants." Other members of Ban's cast of cuteness include the billowing Bonara-kun (named after spaghetti carbonara) and Naizo-kun, a mushy form whose name is a homonym for "internal organs." (*Kun* is a suffix attached to the names of young

men as a sign of endearment.) Ban's playful naming also extends to a forthcoming line of stuffed animals based on Zopants, to be called "Pan-chan"("Pan" is for pants, with an added rhyme to Ban's surname—pronounced with a soft "a," as in "apple.")

Ban's canvases are large (generally more than five feet in height and width), reflecting the proportions of the elephants that she paints. But despite their size, the elephants seem light as air, soft gray shapes. Paired opposites and repeated shapes and colors run through Ban's work,

often in odd configurations. In *Twin Mt. Fuji*, elephant-butterfly hybrids flit about two young girls (whose hair resembles elephants seen from the side). Dresses echo the familiar shape of snow-capped Mount Fuji. A row of trees may be a row of men with lettuce for hair. In *Tower-tongue Zo*, elephants stand on top of one another in an ascending form that parallels the piled scoops of ice cream their tongues are whisking up. But in *Soft-tongued Zo*, ice cream is almost indistinguishable from dung. "It's surprising to see something so heavy become so light, something large

become small, something both ugly and beautiful, something weak but also strong," observes Ban.

In *Picking Up Panties*, Ban says, "When the elephant is mulling over how to get as many pants as possible, thinking, 'What's the most efficient way to get pants?' He sprouts a cactus from the top of his head. It's the same evolutionary process of natural selection that led to the long necks of the giraffe." With the prickly cactus sprouting from the top of his head, this resourceful elephant can zip around and collect the underpants that get stuck on the thorns. While

Ban is fascinated with elephants, her figures seem to have an equal fixation on pants. In fact that's all her trunk-swaying fetishists can see. In *Zokko (Pants)*, a pair is reflected as a twinkle in their eyes. It could be said that underpants serve as the perfect metaphor for a common thread that runs through the work of all these artists: an element once kept under wraps, now exposed to the world.

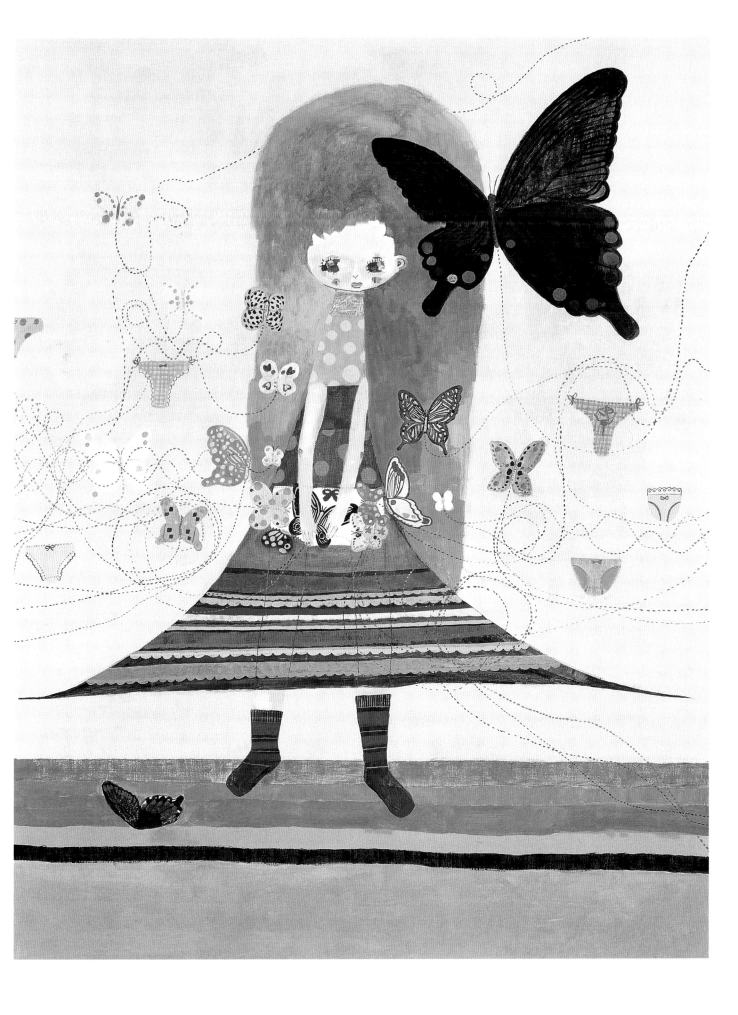

てるてる・パンツに集合

Tefu-tefu (Collecting Pants), 2003.
Acrylic on paper mounted on board. 130.3 × 97 cm.

Twin Mt. Fuji, 2004.
Acrylic on canvas. 130.3 × 162 cm.

106

ふ、た ご　富士

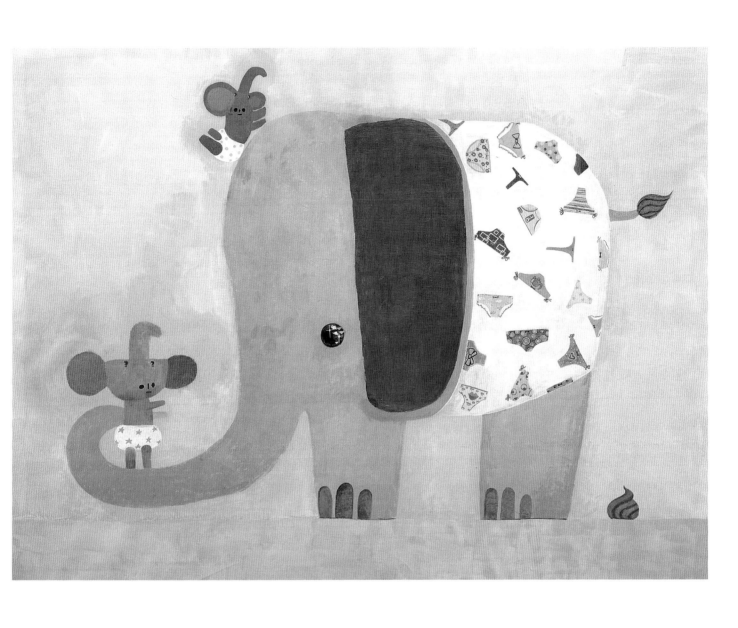

ぞうっ子・ぱんつ

Zokko (Pants), 2003.
Acrylic on canvas. 194 × 259 cm.

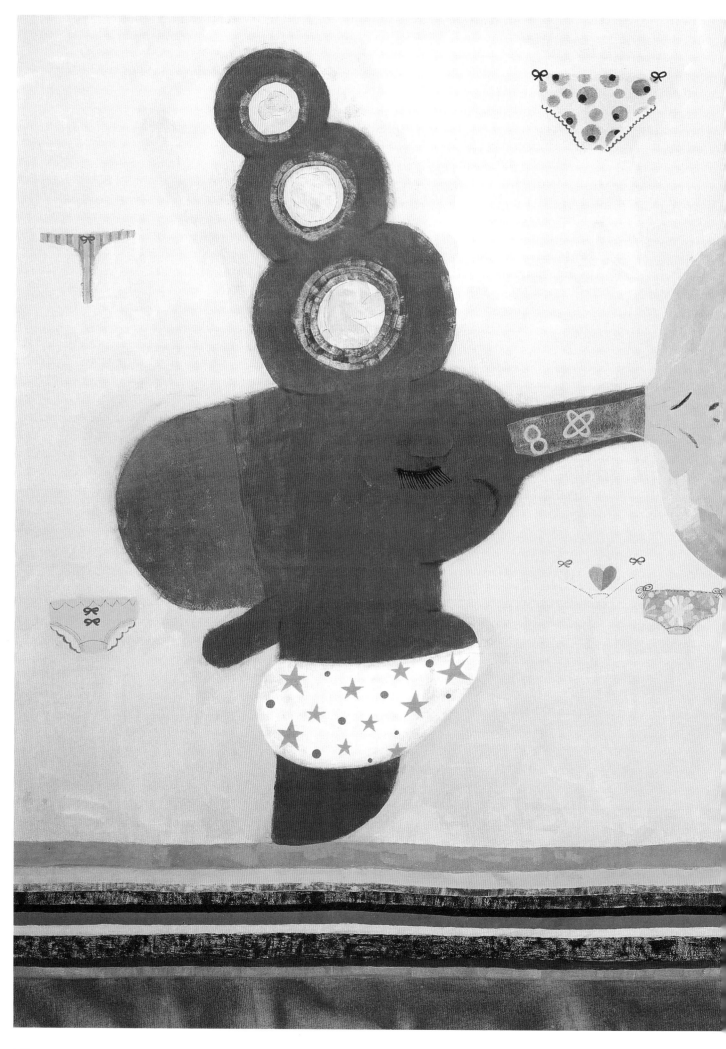

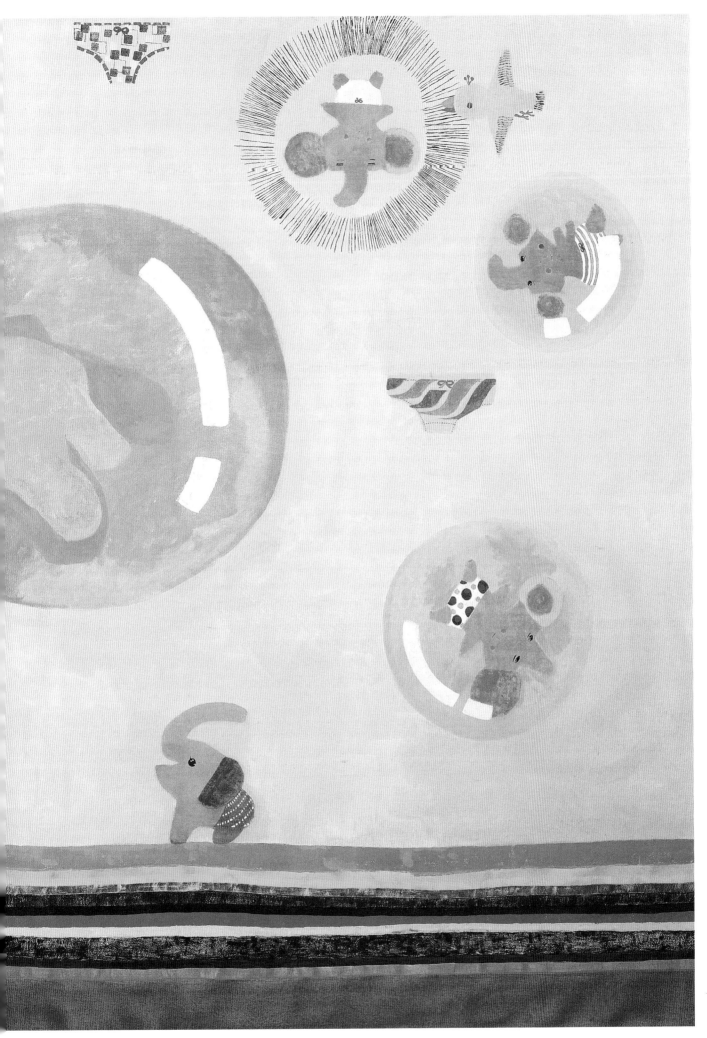

So-zo Pregnant, So-zo Giving Birth, 2004.
Acrylic on canvas. 197 × 291 cm.

ソウゾウ妊娠・ソウゾウ出産

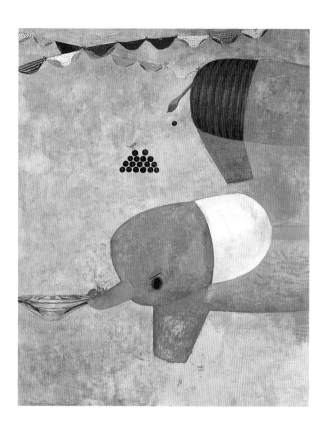

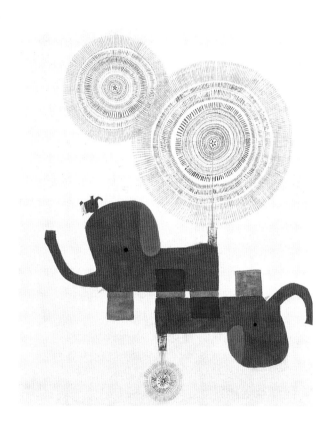

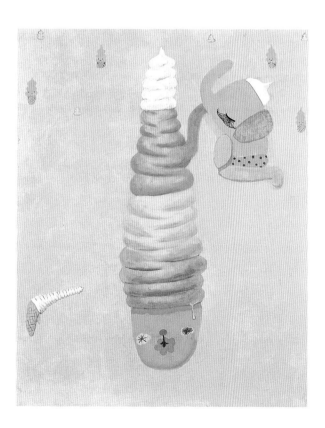

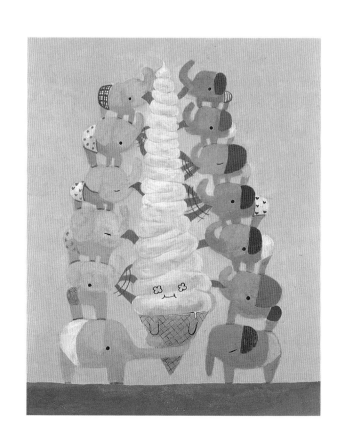

Clockwise from top:
Zokko (Pants), 2003.
Acrylic on canvas. 259 × 194 cm.

Zo (Fireworks), 2002.
Acrylic on canvas. 53 × 45.5 cm. ぞう・花火

Tower-tongue Zo, 2002.
Acrylic on canvas. 65 × 53 cm. タワーぺろぞう

Soft-tongued Zo, 2002.
Acrylic on canvas. 65 × 53 cm. ソフトぺろぞう

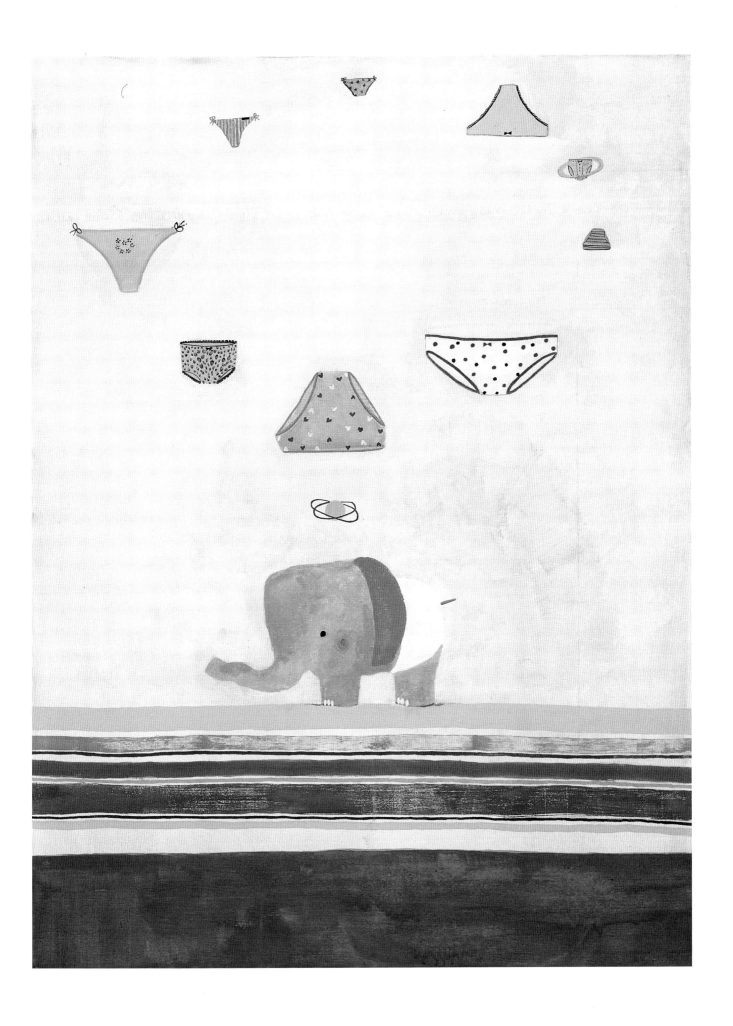

Mercury, Venus, Earth, Mars, Jupiter, Saturn, Uranus, Neptune, and Pluto (Panties), 2002.
Acrylic on canvas. 130.3 × 97 cm.

水金地火木土天海冥（パンツ）

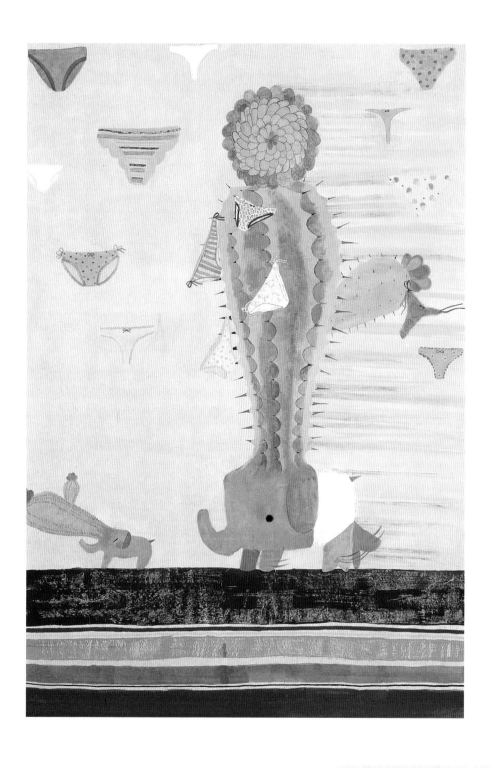

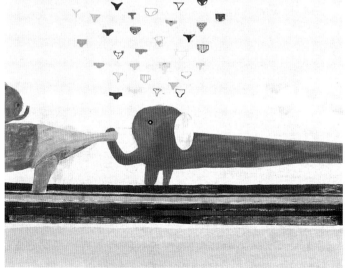

Pich up ぱんつ

Picking up Panties, 2002.
Acrylic on Japanese paper
mounted on panel. 194 × 130.3 cm.

Elephant (Panties), 2002.
Acrylic on Japanese paper
mounted on panel. 59.5 × 84.2 × 1.5 cm.

ぞう・ぱんつ

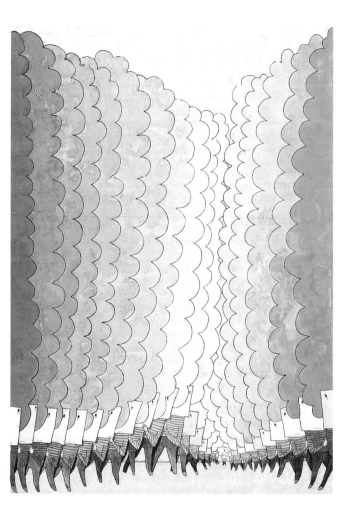

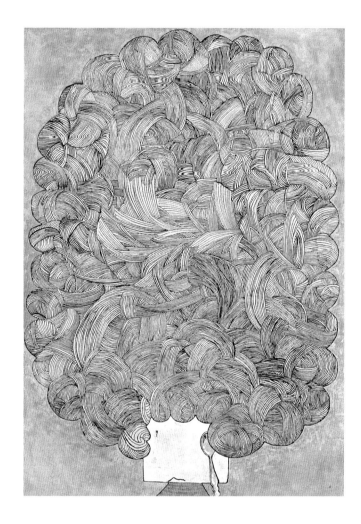

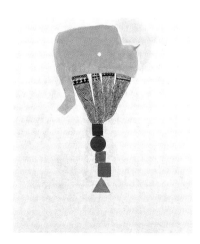

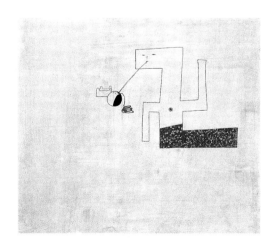

乗るぞう・網岡タイツ

Bottom, left: *Elephants: Mother and Children (Mesh Tights)*, 2002.
Acrylic on Japanese paper mounted on panel. 41 × 31.8 × 2 cm.

神様と内ぞう母（癒してください）

Center: *God and Naizo-mama (Please heal me)*, 1998.
Acrylic on Japanese paper mounted on panel. 45.5 × 53 cm.

はずかしがり屋のボナーうくん

Top, left: *Shy Bonara-kun*, 1997.
Acrylic on Japanese paper mounted on panel. 103 × 91 cm.

Top, right: *Bonara-kun*, 1997.　　ボナーラくん
Acrylic on Japanese paper mounted on panel. 84 × 59.5 cm.

Bottom, right: *Flow*, 2001.　　流
Acrylic on Japanese paper mounted on panel. 41 × 31.8 cm.

113

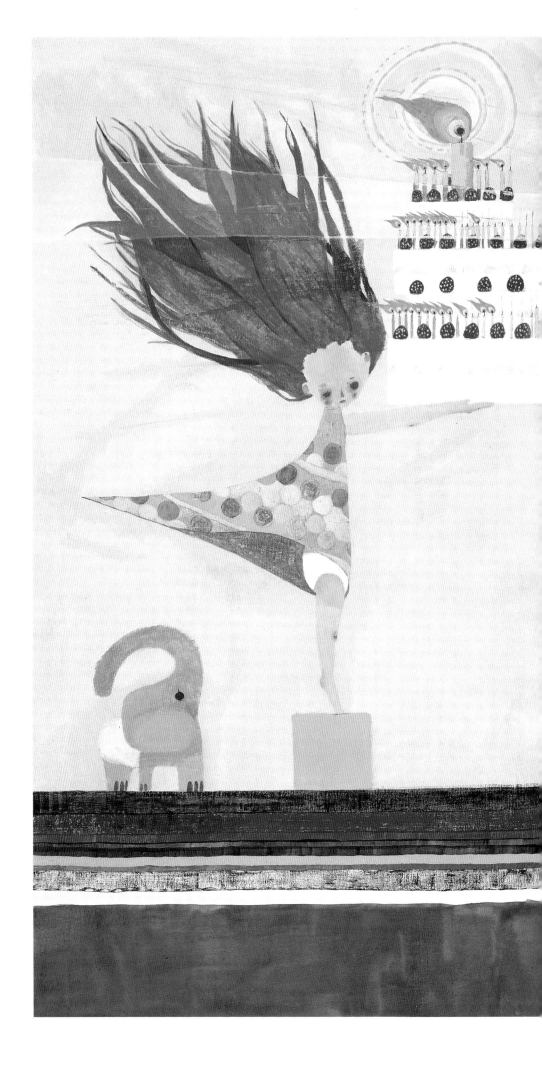

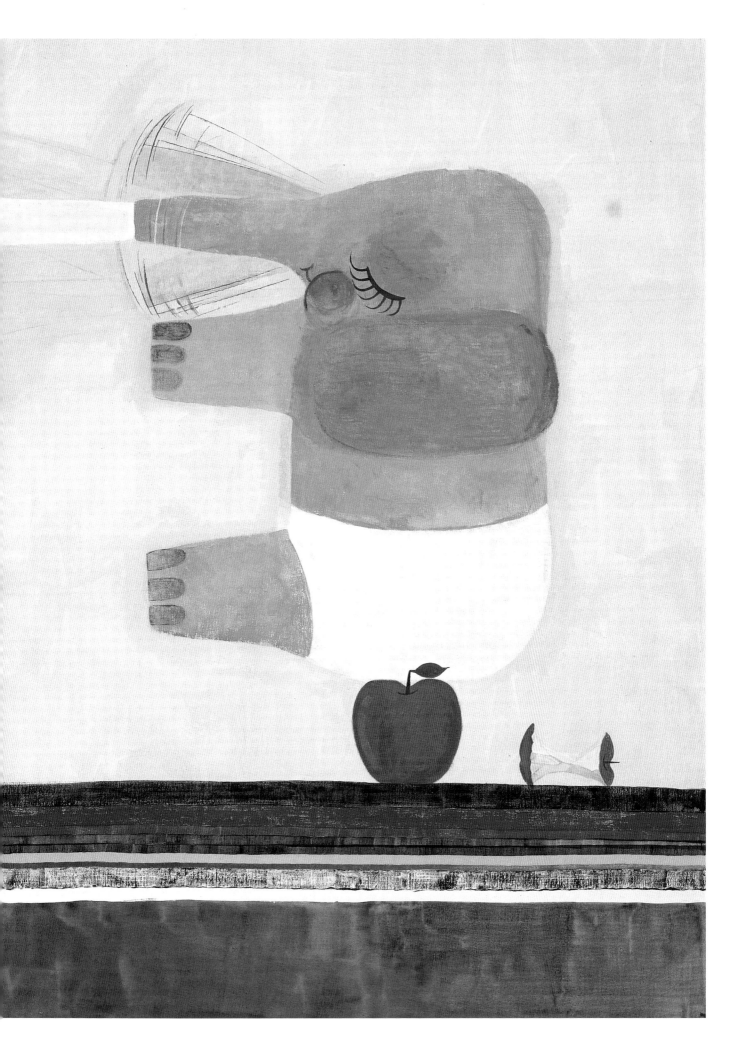

Happy Birthday

Kyoko Murase

IN FEBRUARY OF 2004, Kyoko Murase, who is now based in Düsseldorf, came to Tokyo to install her work in the massive group exhibition "Roppongi Crossing" at the Mori Museum. Her five pieces on exhibit were more of an installation than a simple mounting of the individual drawings and paintings. The pigment of "Girl to the Light," for example, extended beyond the papers' edges onto the white walls, connecting the various works in a larger configuration. Some of the drawings were placed up high despite their small size. In this way, Murase is able to incorporate the entire gallery space into the cosmos of her drawing with a form of metonymy. I was finally able to meet the soft-spoken Murase. Our talk continued via e-mail once she was back at her Düsseldorf studio, her messages composed of half-sentences strung with ellipses, and colored pale-pink or teal—much like the paintings that were the topic of our exchange. "What I can do is draw, but still, there's some place I want to reach. Swaying in my path, turning to the light and extending, searching for the dampness, setting roots—like a bean sprout I want to draw."

The unifying essence of Murase's work is the ethereal and liquid quality with which she renders her shapes. The outlines of female forms are enveloped in waves of water; the longhaired, naked girls that appear in many of the paintings look as if they are swimming, asleep, or perhaps even lifeless. "Even though they float limp—just beginning to sink—there is a moment when something may happen. A picture freezes this one moment and keeps both [sinking and floating] a possibility. It's a tool for capturing the borderline." Despite the calm and repose of her figures,

there is also exhilaration in these images: girls (and sometimes butterflies) alternately surrender to and emerge from watery ripples. Murase denies that death is an intended theme in her work, and talks instead of the senses. "Water is a continual element, certainly. I often use the image of a pool, or a drum of water, or a bath. Something without current. It envelops you quietly, filling your senses once you are inside. Recently, though, [in my work] there is some slow motion, like a washing machine starting to move, like the flow of hair, or the shimmy of a skirt. Actually, it

花粉

Pollen, 2004.
Pigment, gouache, and pencil on paper. 30 × 40 cm.

doesn't have to be water. It could be anything. Fog, cloud, ocean. Something that is slightly chilly and damp."

In her series "Girl to the Light," the light source rendered in the drawings is at the paper's edge, radiating into the image, whereas in the series "Lights in the Forest," an illuminating sphere is more centrally within the frame. Rather than a single, directed ray of light, the white circles within the compositions are like bursts of illumination refracted through a prism. "When you are speeding down the highway, in the distant sky, the sun's rays poke through the clouds and extend all the way to the ground. Seeing light with your naked eyes is like that too. The movement of the girls . . . the undulations of their hair . . . drawing water or a fog is an attempt to express what's going on inside the girl. That's what it's about. What cannot be seen becomes visible through some medium." The effect of that rendering can be breathtaking.

118 *Pollen*, 2004.
Pigment, gouache, and pencil on paper. 30 × 40 cm.

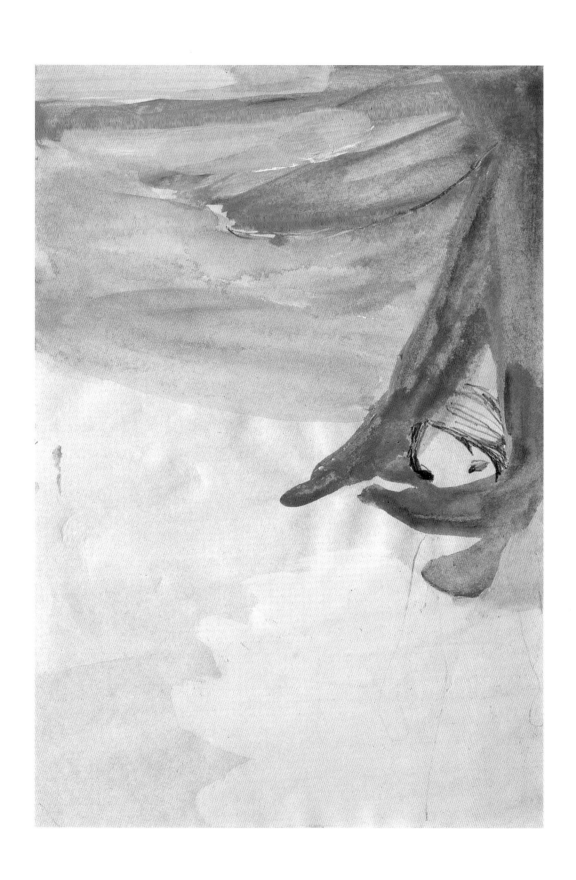

 Untiteld

Untitled, 2001.
Pigment and pencil on paper. 25 × 17.3 cm. Private collection.

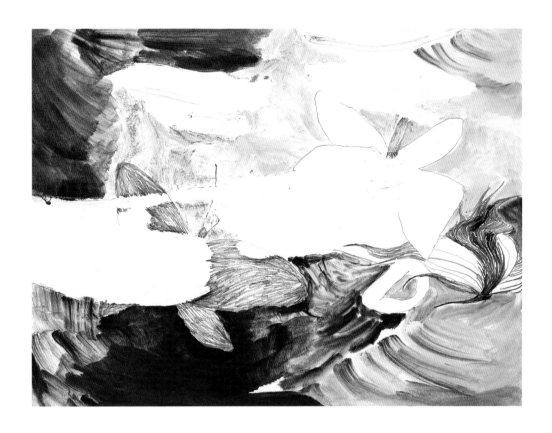

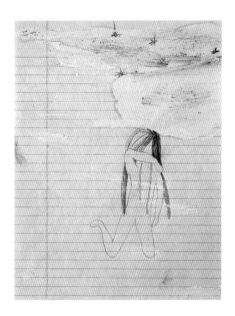

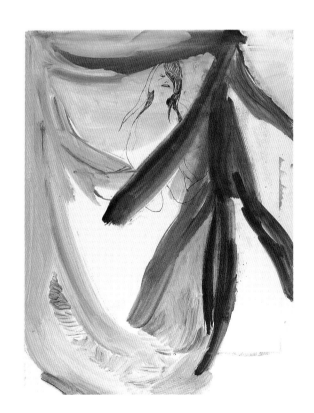

Nap

Top and opposite: *Nap*, 2003.

Pigment and pencil on paper. 30 × 40 cm each.

120 TAKAHASHI Collection.

Untitled, 2003.
Pigment and pencil on paper. 28.1 × 21.6 cm.

Chasing Butterflies, 2002.
Pigment and pencil on paper. 56 × 42 cm.
Collection of Robert and Naomi Green.

Untitled

Chasing Butterflies

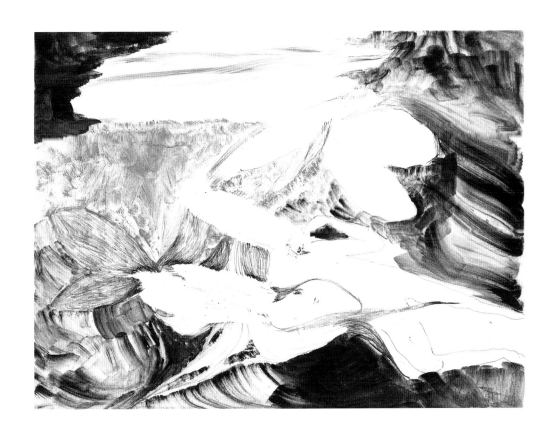

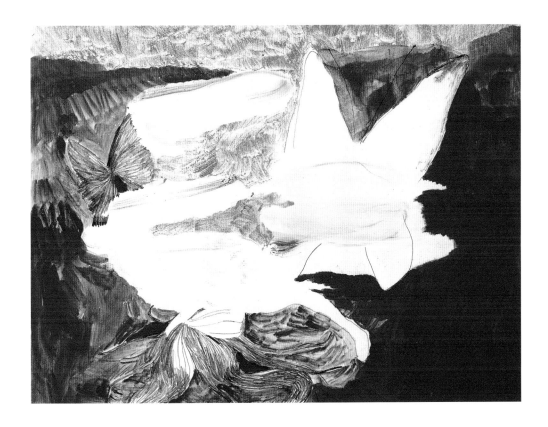

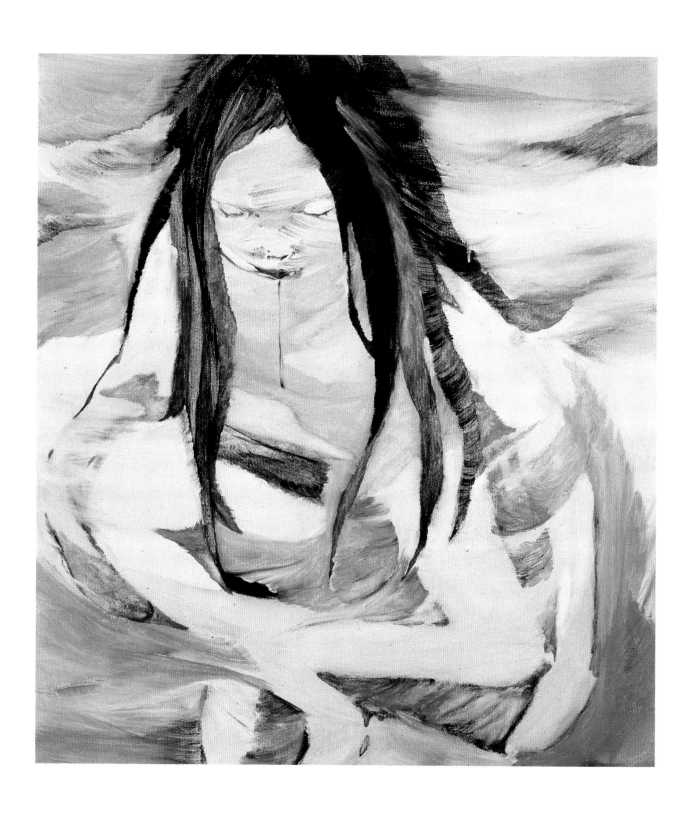

Punch

Punch, 2003.
Oil on cotton. 64 × 58 cm. Ugeyan Collection.

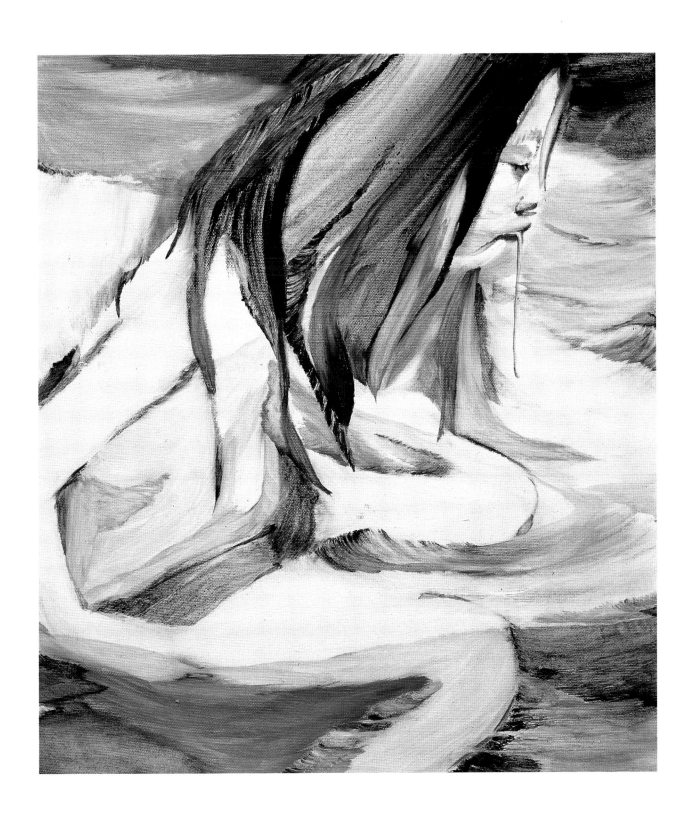

At the Lake

At the Lake, 2004.
Oil on cotton. 64 × 58 cm. Private collection.

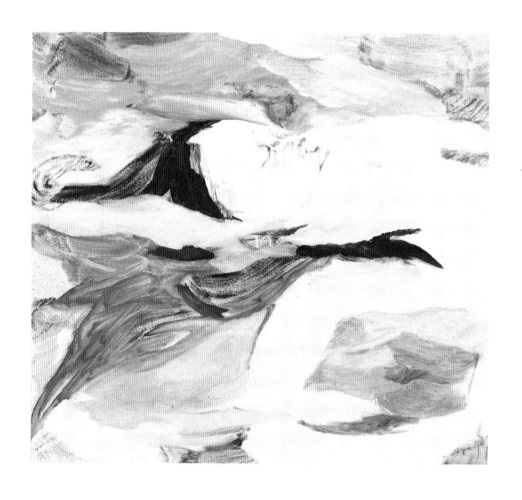

Eliza

Eliza, 2000.
Oil on cotton. 50 × 55 cm. Private collection.

Opposite: *Surfboard*, 2001.
Oil on cotton. 68 × 62 cm. Private collection.

Surfboard

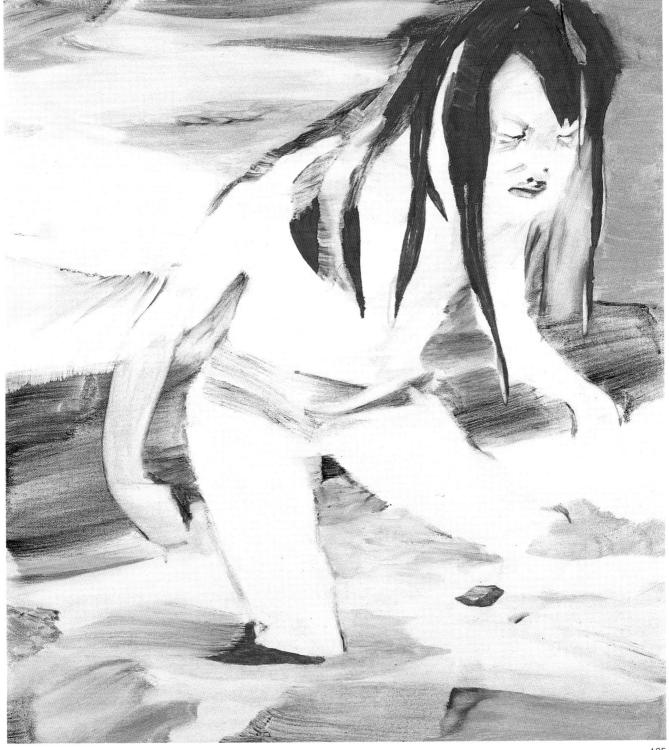

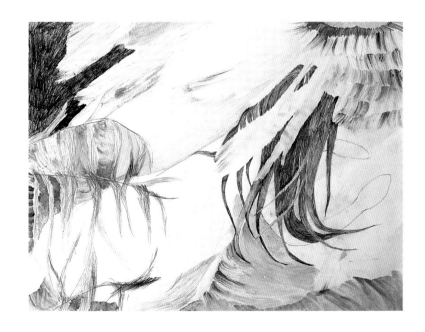

Girl to the light

Pages 126–127: *Girl to the Light*, 2004.
Pigment and pencil on paper. 80 × 60 cm each.
All works TAKAHASHI Collection with the
exception of Top, Right: Private Collection.

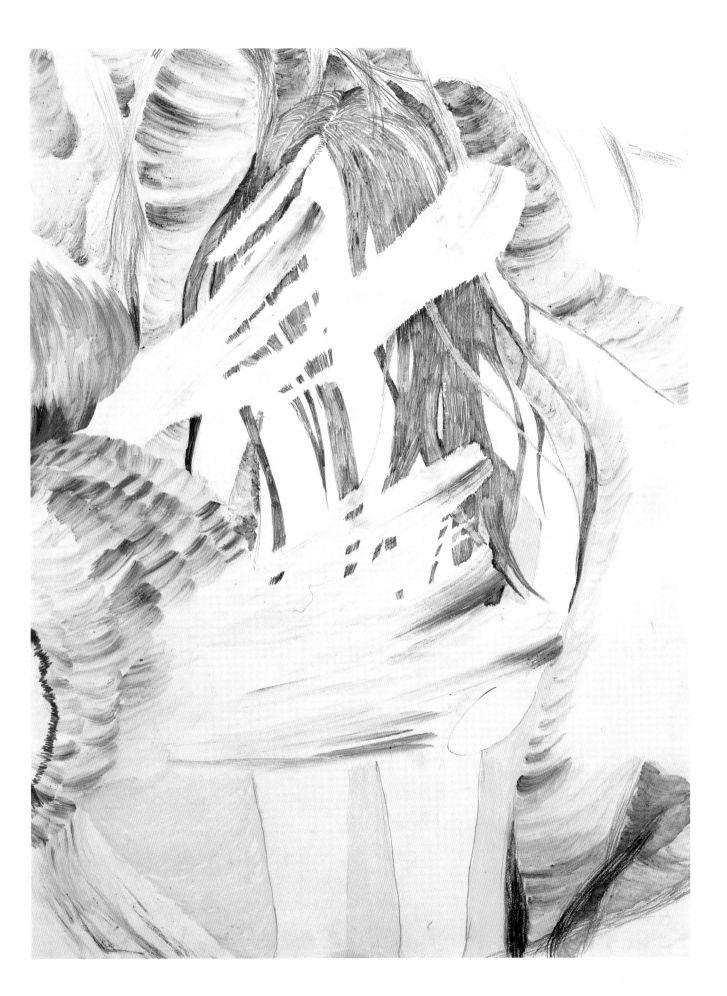

Girl to the light

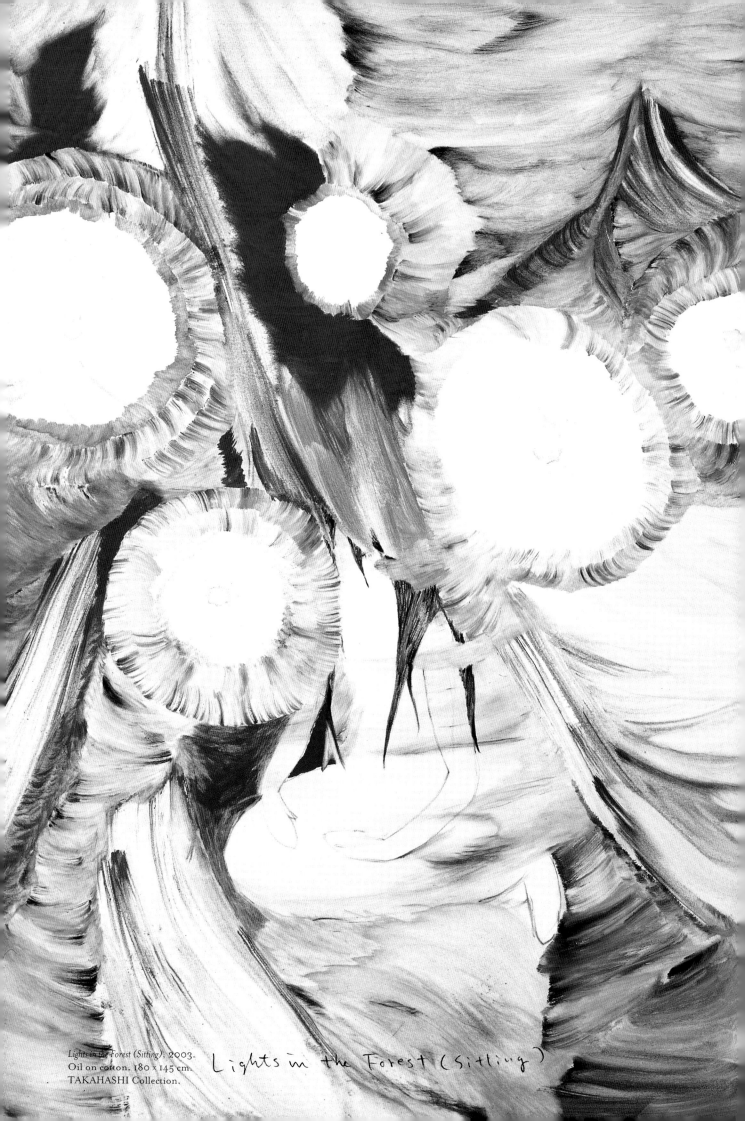

Lights in the Forest (Sitting), 2003.
Oil on cotton. 180 × 145 cm.
TAKAHASHI Collection.

Lights in the Forest (Sitting)

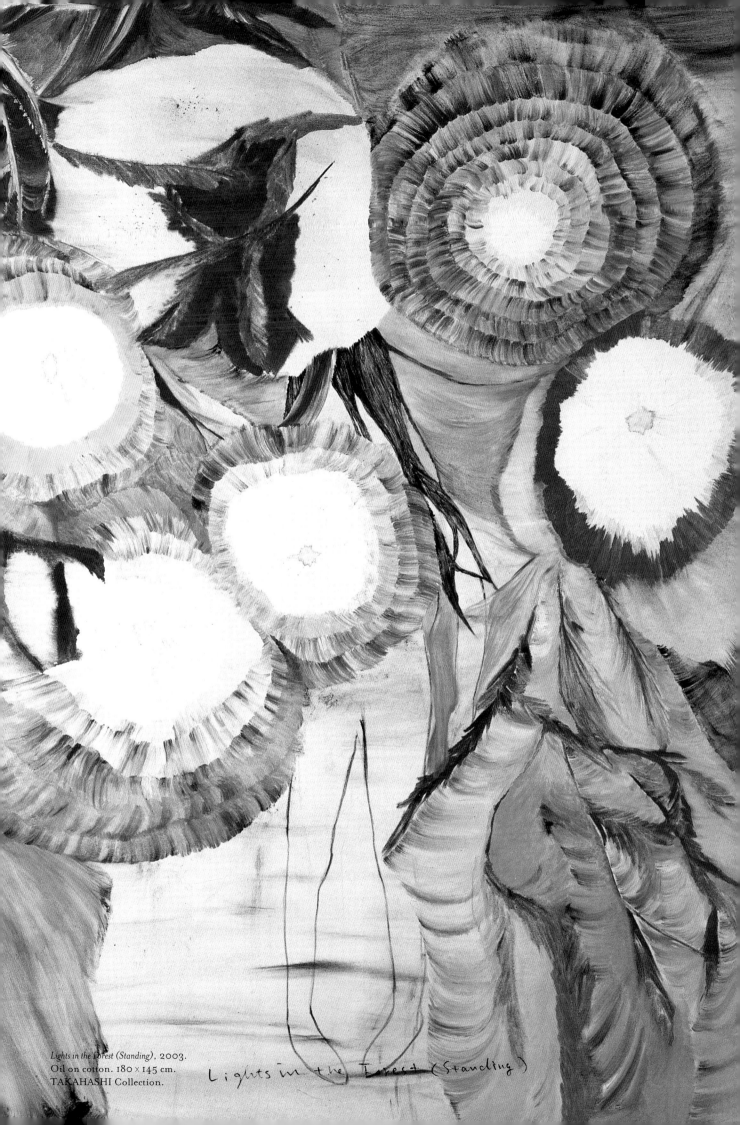

Lights in the Forest (Standing), 2003.
Oil on cotton. 180 × 145 cm.
TAKAHASHI Collection.

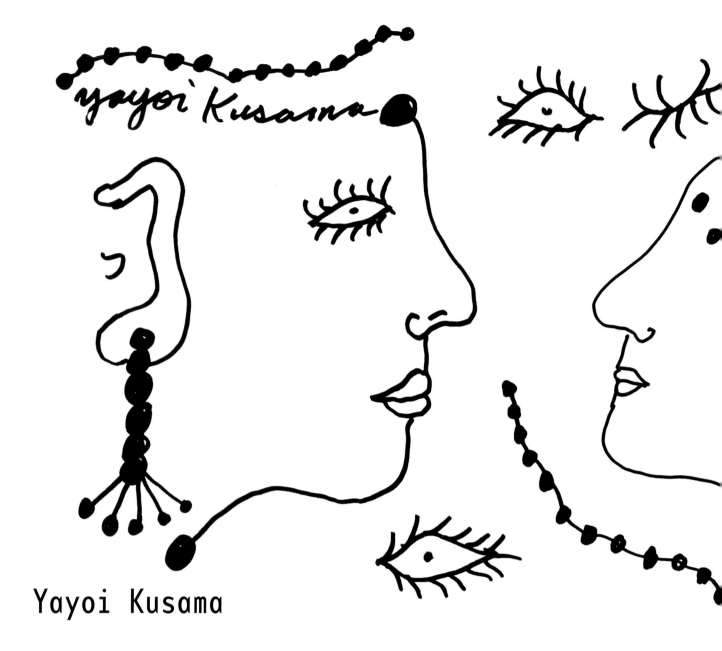

Yayoi Kusama

YAYOI KUSAMA WAS AT the forefront of the Pop Art explosion of the early 1960s, showing her work alongside the soft sculptures of Claes Oldenburg and the multiples of Andy Warhol. Her own soft sculptures may even predate those of Oldenburg, while her repetitive paintings of vertigo-inducing "infinity nets" and phalli-covered objects helped to define such art world tropes as "accumulation art" and "obsessional art."

So it came as something of a surprise that the woman behind all this is quite small—almost pint-sized—but then, Kusama's intellect is massive. And her unusually large eyes seem to peer through you, rather than look at you. These eyes figure prominently in her self-portraits, with the pupils replaced by concentric rings of dots. The sense of disorientation that is captured in these portraits pervades all of her work. In installations, the infinite reflections of

facing mirrors are like an inescapable maze of the self. The repetitive aspect of her work—which often entails performing an action or creating an image over and over, *ad nauseam*—can also be seen as a series of expansions. To create a phalli-covered piece, for example, she first draws a dotted pattern on fabric. Then the material is cut, stuffed, and sewn into the shape of phalli, hundreds, *thousands* of times, until the colonies of phalli are plentiful enough to fully cover the sides of a table, sofa, or an abstract, boatlike, tumescent growth. Then the table, sofa, or growth is placed in an installation, which is photographed. These photographs are cut up and used in a collage, and then another creation picks up from there, in an ongoing and never-ending process.

Kusama's work mimics the infinite, or more precisely, the "limitless," with each unit repeated until a new level of

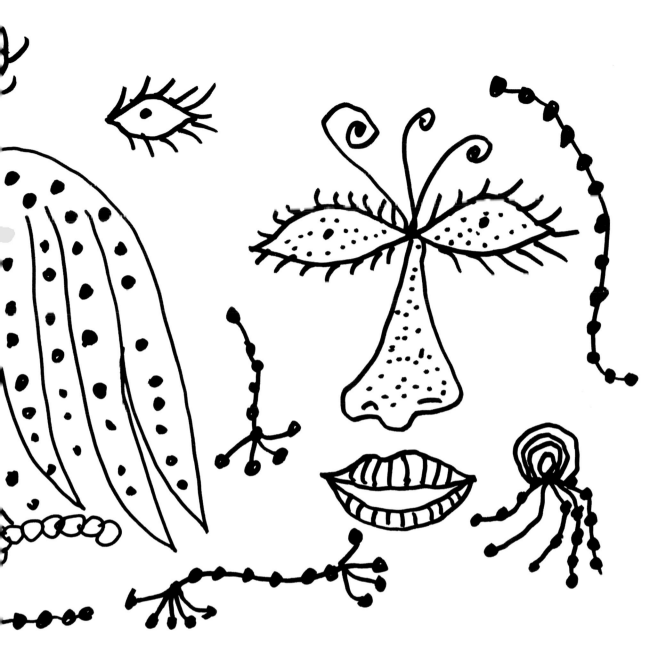

complexity is added. Her work inflates exponentially, from a single dot to the surface it covers, to the volume defined by the surface, to the object covered by the surface, to the room filled with covered objects, to the installation of rooms in an exhibition, and then to the touring of the exhibition itself from museum to museum. In this way, the museum becomes yet another dot in a stream of dots. (Kusama has considered pinning red flags on a world map to indicate all the venues where her work has been shown.) Indeed, the nature of her creativity is obsessive-compulsive, and the artist's feverish pace of working has caused her both physical and mental strain. From 1973 on, she has lived, of her own accord, in a mental institution as an outpatient. Regardless, her productivity remains undaunted even now at age seventy-six. Recently, for the first time in Kusama's career, she has

introduced an element of lightness into an otherwise daunting body of work. Her series of doll-like figures is called "Hi, Konnichiwa" (pages 138–139). As she explains, the title is an exuberant greeting to young women everywhere: "Youth from afar is coming closer. The day approaches when the universe of unknown beauty of young women will spread out. I extend my hand out to them and call, 'Hi, Konnichiwa.'"

These figures, and the giant sculptures that dwarf the spectator, are subject to Kusama's familiar dot-dot-dot process of production. First, she created a series of drawings of doll-like girls; then she turned the figures into three-dimensional sculptures; then she surrounded those sculptures with three thousand iterations of the primary drawings. Next, Kusama invited fashion-design students to create costumes based on the figures for a fashion show.

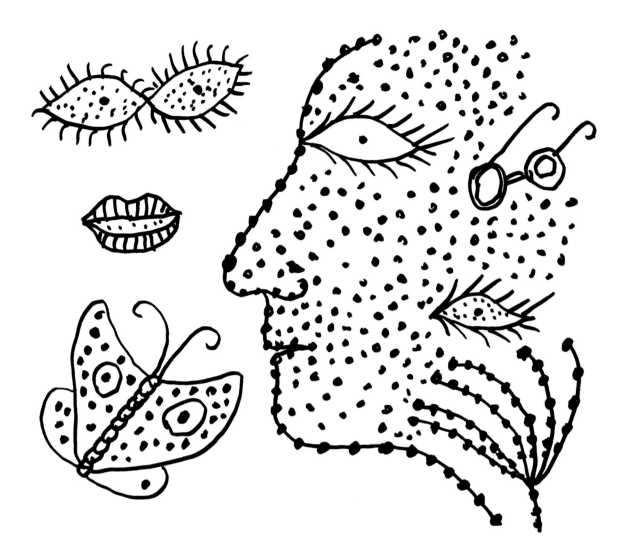

She has also given some of the figures diminutive nicknames, such as "Meeko-chan," "Chee-chan," and "Taah-chan." These names may constitute a way of saluting the individual girls/dolls, in the same way that Kusama "extends her hand" to the younger generation. She says of these cute drawings that she wanted to depict a *happy* world, in contrast to the painful experiences of her own childhood and adolescence.

Instead of idealizing or oversimplifying youth, these works foreground the conflict between lightheartedness and obliteration. This is the underlying connection between Kusama and the rest of the artists in this publication. *Cuteness* is not a stable entity in the hands of these women; there is always an underpinning of darkness and destruction, not far below the veneer of charm and emotional tangibility. Each of the artists possesses an awareness of this dichotomy in their various manifestations of *cute*, either overtly pairing the cute and sweet with themes of threat and annihilation, or otherwise acknowledging the forces of chaos. Kusama makes the connection between *cute* and *uncute* clear with her character Taah-chan, for instance, who is enveloped by thick, snakelike coils covered in a yellow-black dot pattern. (Kusama wore a dress with the same dot pattern when we met.)

"Everything is obliterated with dots," Kusama says. "The flipside of youth is death." Her young girls are not only trapped in decay, they are its very essence.

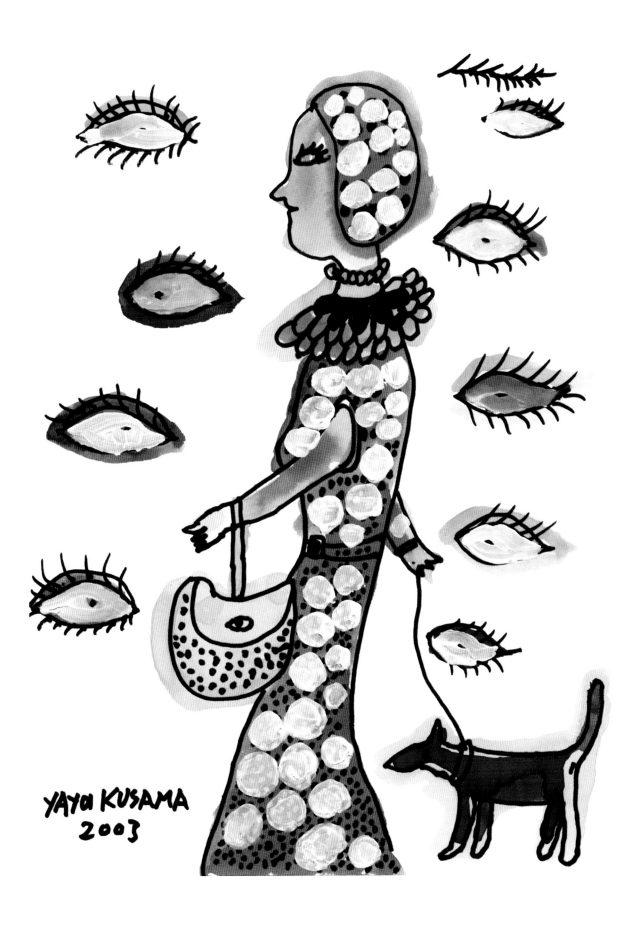

YAYOI KUSAMA
2003

A Thaw. Spring Has Come, 2003.
Ink and acrylic on paper. 36.4 × 25.7 cm.

A Thaw. Spring Has Come

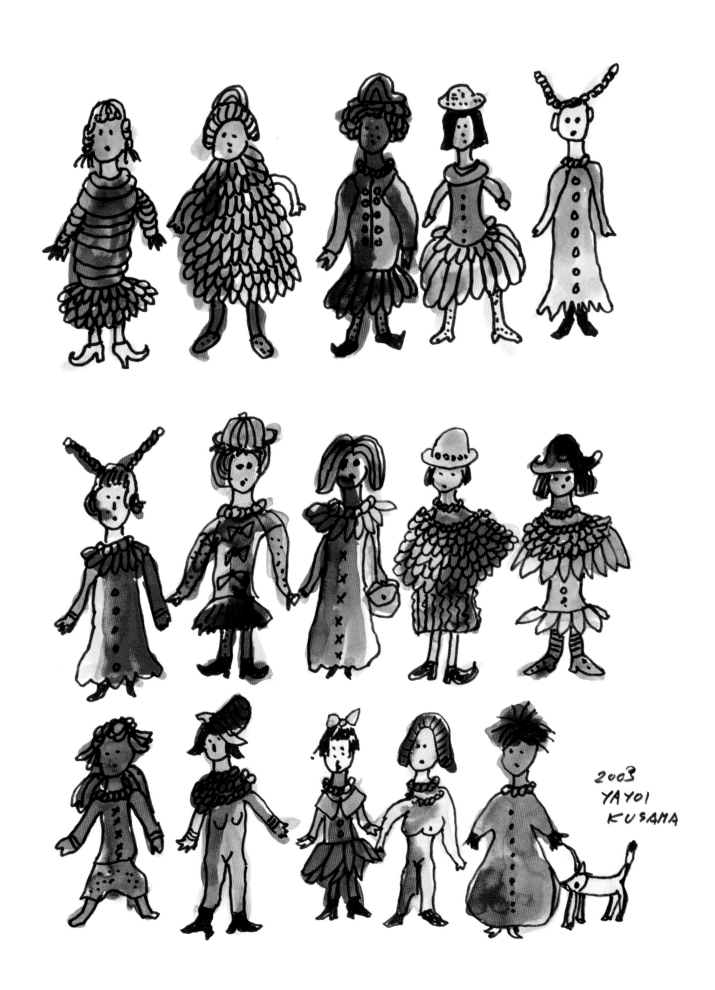

After School, 2003.
Ink and acrylic on paper. 36.4 × 25.7 cm.

After School

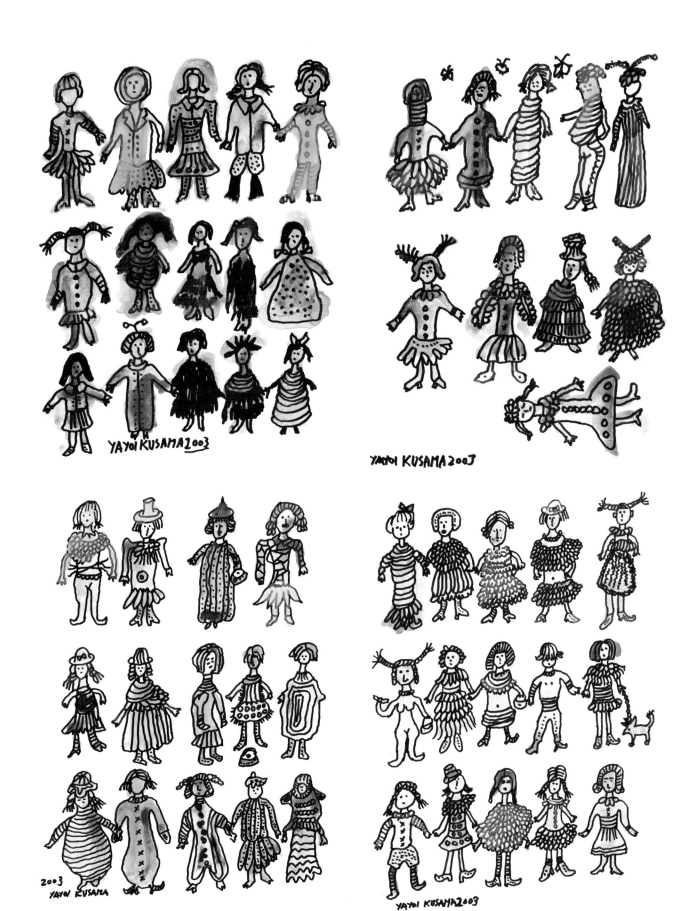

Top, left: *15 Girls (TZOA)*, 2003.
Ink and acrylic on paper. 36.4 × 25.7 cm.

Bottom, left: *14 Girls (ZQWA)*, 2003.
Ink and acrylic on paper. 36.4 × 25.7 cm.

Top, right: *10 Girls (WHTOL)*, 2003.
Ink and acrylic on paper. 36.4 × 25.7 cm.

Bottom, right: *15 Girls (ATWOT)*, 2003.
Ink and acrylic on paper. 36.4 × 25.7 cm.

15 girls TZOA

10 girls (WHTOL)

15 girls (ATWOT)

14 girls (ZQWA)

135

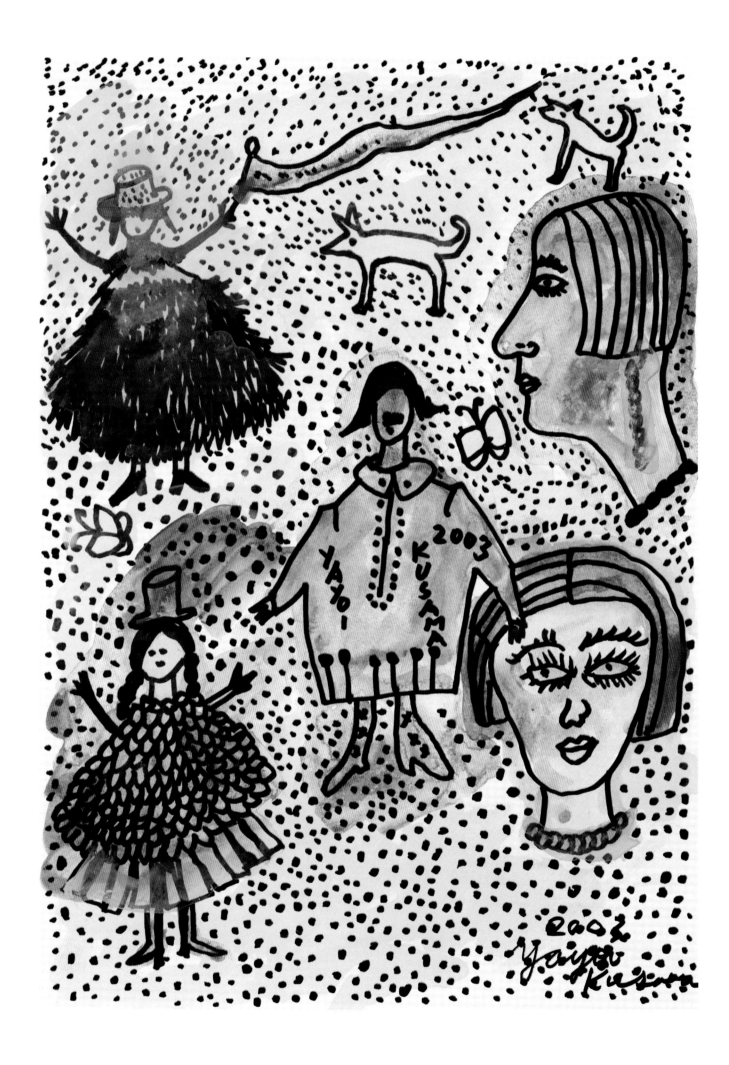

Girls (WHTQ), 2003.
Ink and acrylic on paper. 36.4 × 25.7 cm.

girls (WHTQ)

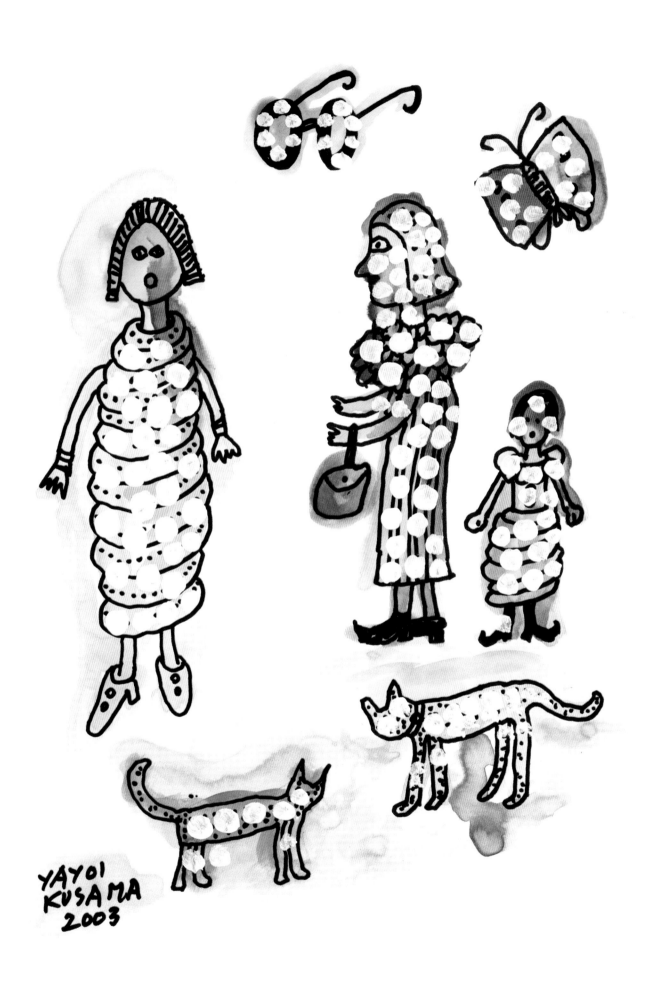

THE END OF a snowfall

The End of a Snowfall, 2003.
Ink and acrylic on paper. 36.4 × 25.7 cm.

137

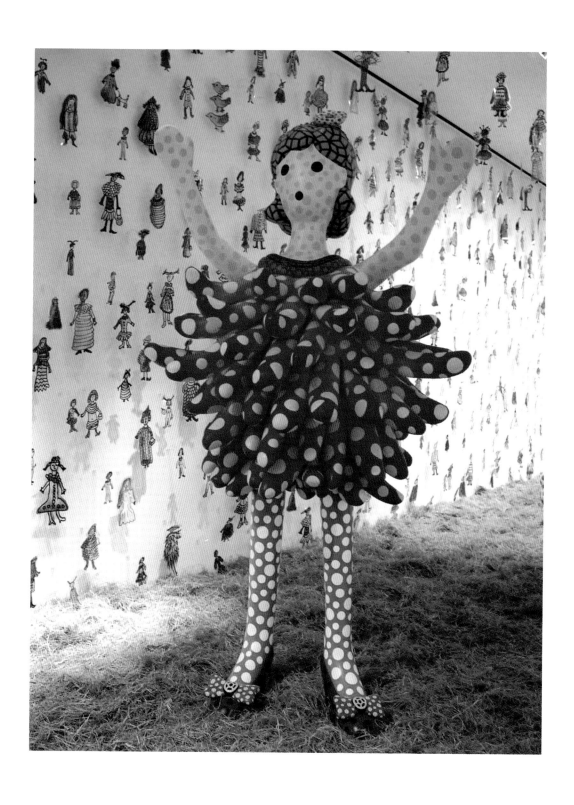

Hi, Konnichiwa (HELLO!) Yayoi-chan

Pages 138–139: Installation views of the exhibition
"KUSAMATRIX: Kusama Yayoi" held at the Mori Art Museum, Tokyo.
This page: *Hi, Konnichiwa (Hello!) Yayoi-chan*, 2004.
Mixed media. 268 × 148 × 113 cm.

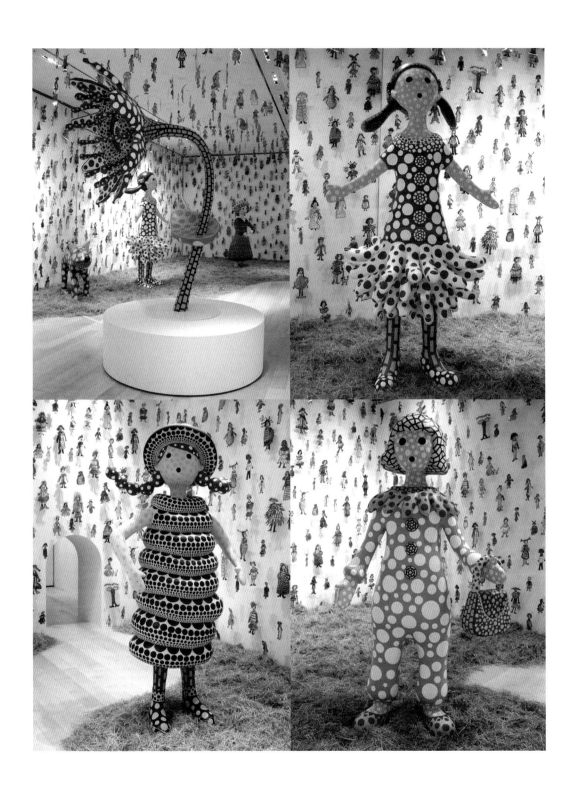

Hi, Konnichiwa (Hello!) Hanako

Top, left: *Hi, Konnichiwa (Hello!) Hanako*, 2004.
Mixed media. 254 × 145.5 × 186 cm.

Hi, Konnichiwa (Hello!) Taa-chan

Bottom, left: *Hi, Konnichiwa (Hello!) Taa-chan*, 2004.
Mixed media. 268 × 143 × 108 cm.

Hi, Konnichiwa (Hello!) Miiko-chan

Top, right: *Hi, Konnichiwa (Hello!) Miiko-chan*, 2004.
Mixed media. 268 × 143 × 108 cm.

Hi, Konnichiwa (Hello!) Nao-chan

Bottom, right: *Hi, Konnichiwa (Hello!) Nao-chan*, 2004.
Mixed media. 268 × 143 × 108 cm.

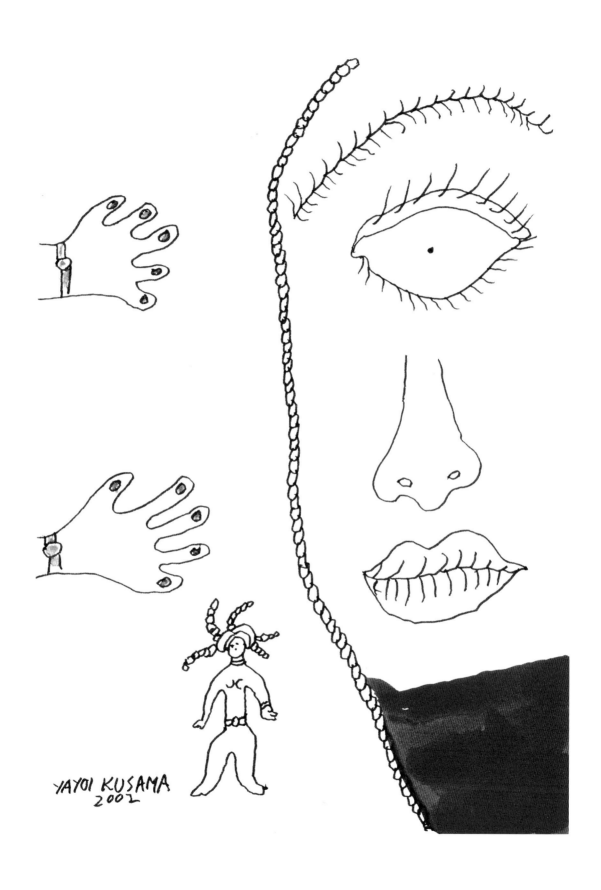

Let's Go to the Field, 2002.
Ink and acrylic on paper. 25.7 × 18.2 cm.

Let's Go to the Field

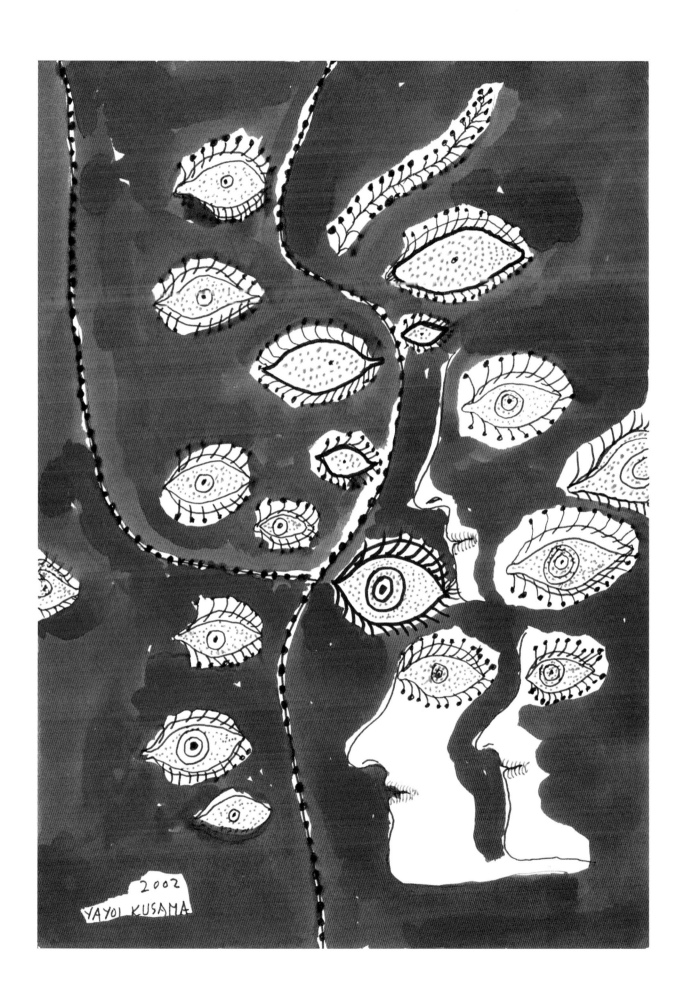

Accumulation of Eyes, 2002.
Ink and acrylic on paper. 25.7 × 18.2 cm.

Accumulation of Eyes

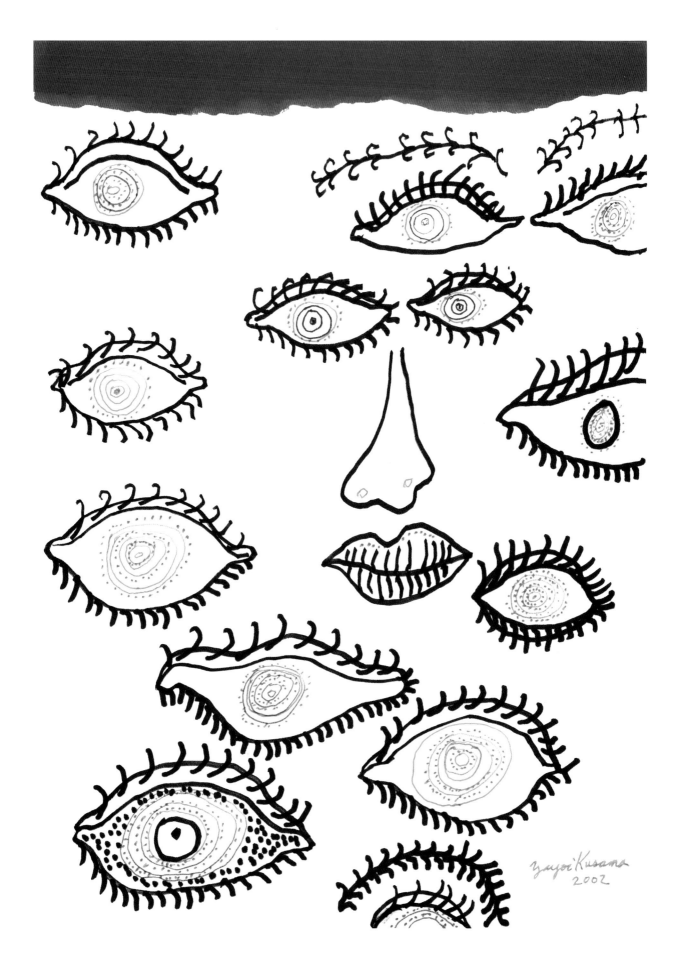

SELF-portrait

142 *Self-portrait*, 2002.
Ink and acrylic on paper. 36.4 × 25.7 cm.

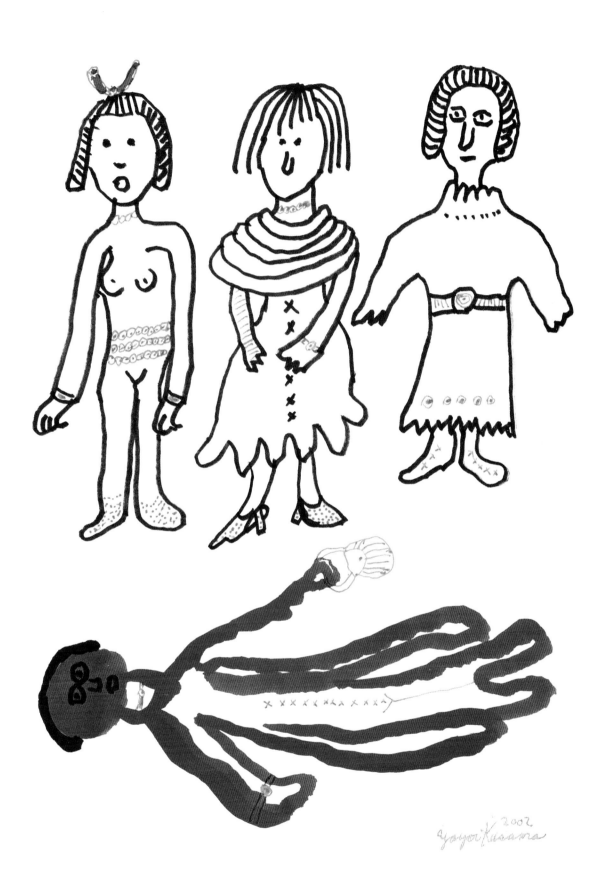

Four Young Women, 2002.
Ink and acrylic on paper. 36.4 × 25.7 cm.

Four Young Women

Tabaimo

ALTHOUGH ENGLISH WORDS APPEAR fairly commonly on Japanese T-shirts, it was still somehow surprising to see a young Japanese woman sporting the slogan "I HATE SEX" across her chest. "Yeah," Tabaimo said, "my mother often says I wear weird things." Beneath the lettering was an illustration with the trademark style of Japan's legendary designer of the psychedelic, Keiichi Tanaami. Tabaimo attributes her career path to his influence as an educator and artist. Our T-shirt discussion also sparks an animated reminiscence between Tabaimo and a gallery assistant who is attending our meeting. The two girls erupt into peals of laughter about the "loose socks" phenomenon—comically oversized, white

knit legwarmers, which was part of Japan's *joshiko-buumu* (high school girl boom) of the late '90s. It's a display of light-heartedness I also hadn't expected of an artist whose work is so powerfully disturbing, macabre, and engrossing.

Tabaimo makes short animated films that vary in length from about four to about ten minutes. In their completed form as installations, the films are projected onto screens (ranging from a panorama of six panels to a single screen). Tabaimo executes the labor-intensive process of production herself, creating between four and thirty individual frames per second of film. Each cell is drawn by hand and then colored and animated by

computer. Almost all of the images reproduced here are recomposed images, assembling the characters and scenes from each of the animations into single stills.

The theme of horror in Tabaimo's work is inextricably woven into everyday events. In *Nippon Tsukin Kaisoku* (Japanese Commuter Express Train), a baby hangs by the neck from a strap-handle within the humdrum scene of a commuter train. In *Nippon no Daidokoro* (Japanese Kitchen)—of which approximately a thousand frames have been reproduced here in sequence—a father figure has lost his job as the result of corporate downsizing—and to add injury to insult, his head is sliced off by a grim woman. ("Cutting the neck" is a literal translation of the colloquial Japanese term for "getting fired.") "The themes of my animations are what you'd ordinarily see on the news, which for the longest time didn't feel real to me at all," Tabaimo notes. "The amount of information pouring in is so overwhelming that it is impossible to process it all. That is the reality of people today. . . . My animations line up the terrible episodes I see in daily life. The characters are emotionless, although what happens before them is horrific. The animations remind the spectators that each of these incidents has happened in reality. Even though we are the protagonists in our own real world, we have absolutely no response to what is

occurring right before our eyes. That's something that fills me with terror."

Tabaimo uses to full effect the culture of the moving image to elicit a powerful response from her viewers. "There are many Japanese who feel so strongly for manga and anime characters that they lose all awareness that what they are reading is purely *unreal*. This is particularly the case with people of my generation and the generation after mine. From childhood, we have a very strong connection with it. It's a social phenomenon that results in certain problems. On the other hand, it has also yielded a new world in the spaces between the real and the unreal. That's because of the sense of ambiguity that's particular to Japanese culture. It's a world that doesn't exist in the West. In contemporary Japan, many people find realness in the worlds of anime and manga while real-time news feels unreal. That's the reason why what I draw in my animations brings out a sense of pain, although it is exactly the same [event] that I have lifted from the news. This is . . . why the animations that I have created are meant for Japanese viewers." Ultimately, though, the scenes of quotidian horror in Tabaimo's work not only detail how we have become the architects of our own destruction, they also serve as the impetus for our awakening.

Pages 147–149: From *hanabi-ra*, 2003.
Recomposed original drawings.

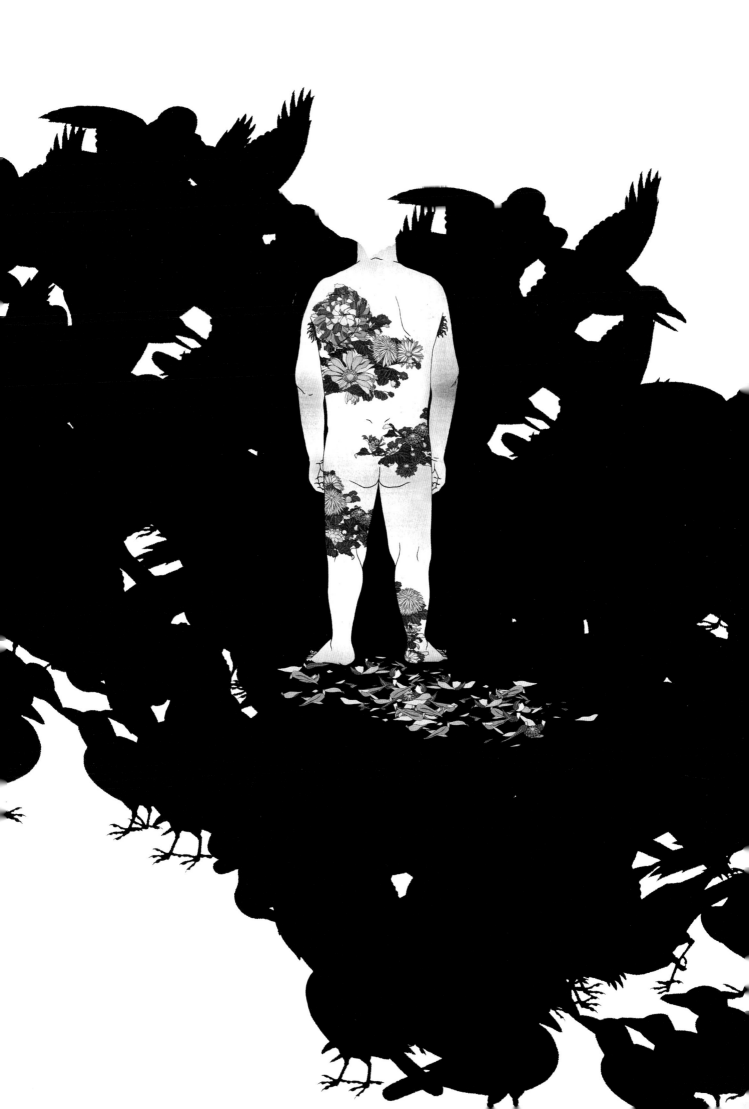

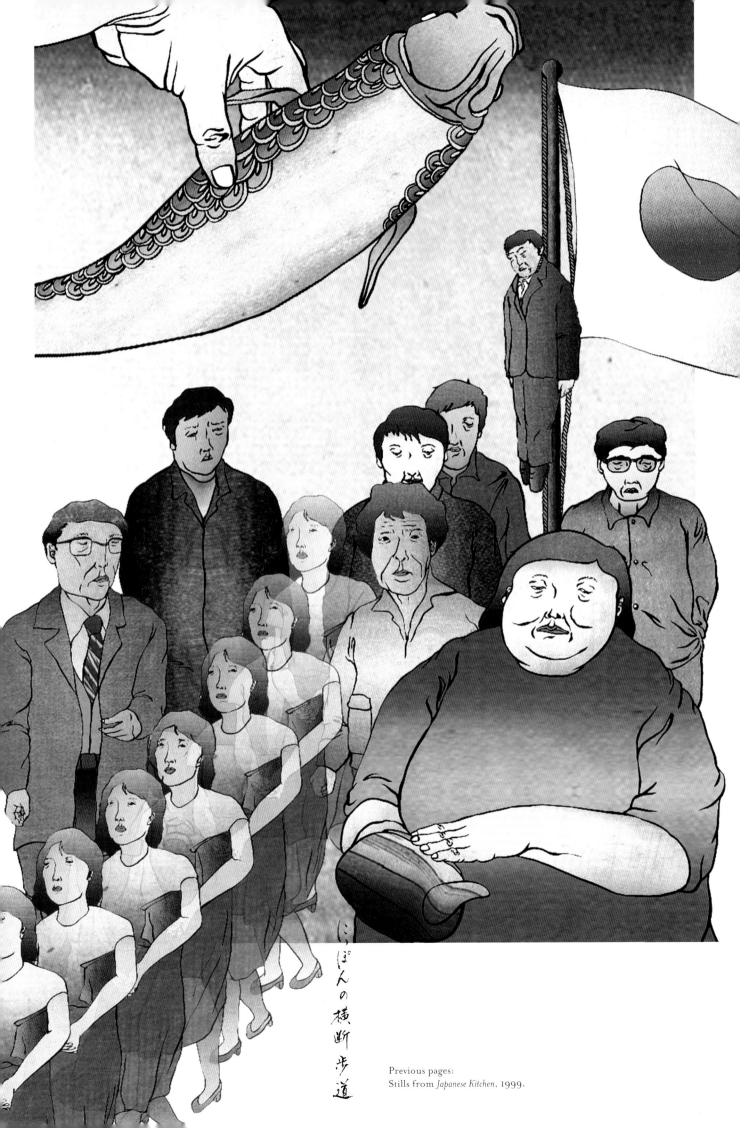

にっぽんの横断歩道

Previous pages:
Stills from *Japanese Kitchen*, 1999.

Opposite: From *Japanese Zebra Crossing*, 1999.
Recomposed original drawing for print.

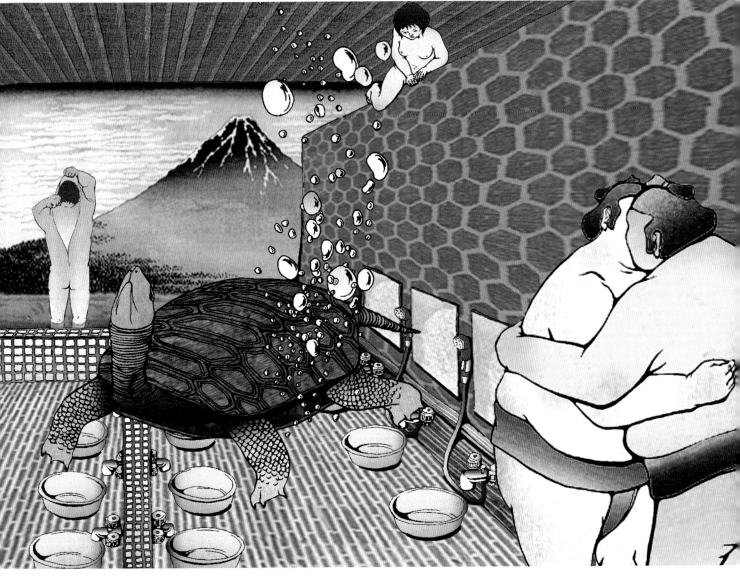

にっぽんの湯屋（男湯）

From *Japanese Bath*, 2000.
Recomposed original drawing for print.

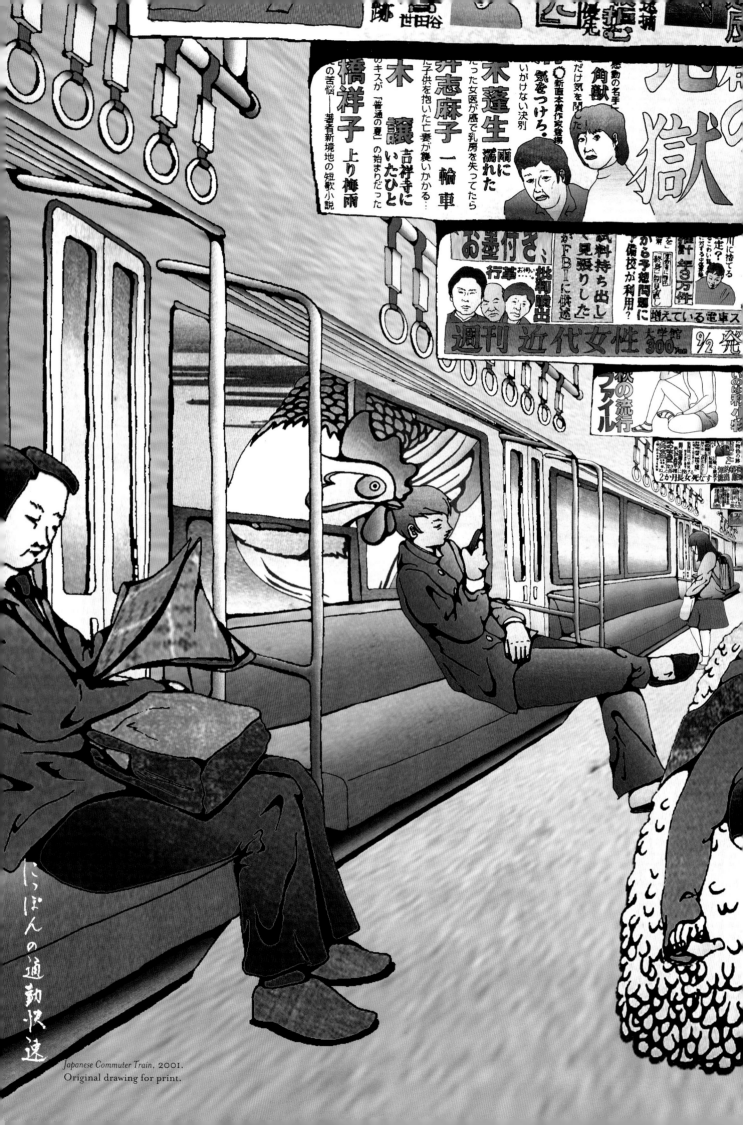

Japanese Commuter Train, 2001.
Original drawing for print.

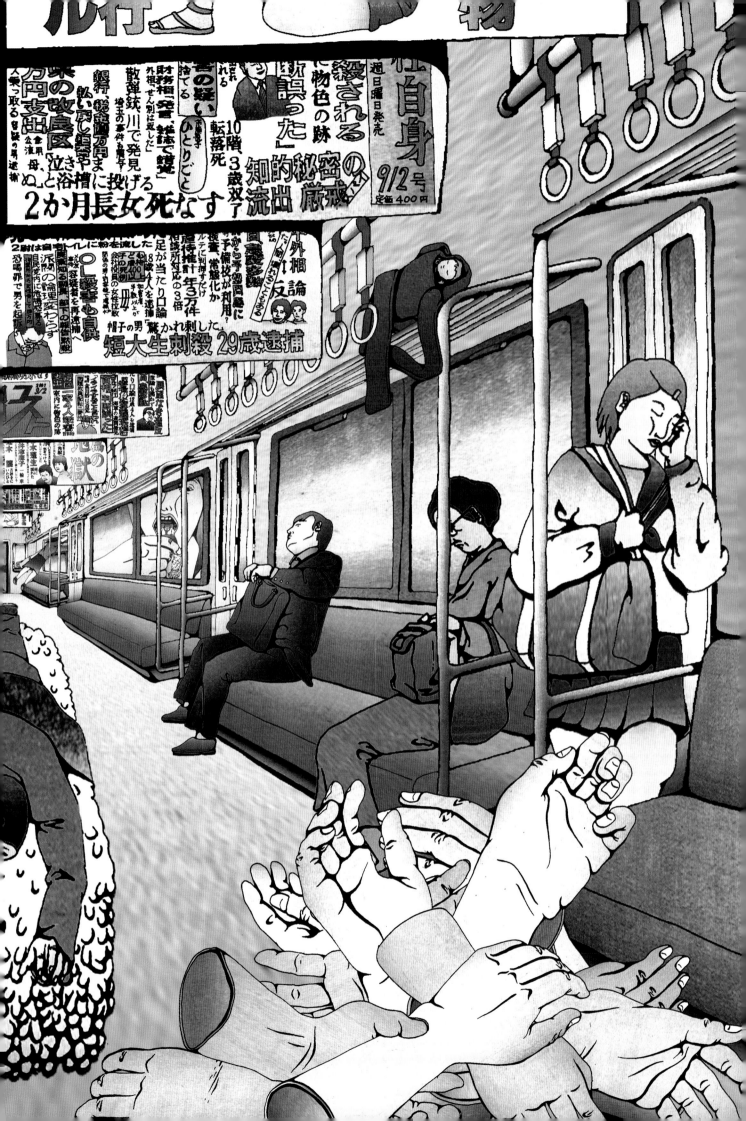

Molti crimini

In the Kitchen, 2004.
Original drawings installed at the Fondazione Sandretto Re Rebaudengo.

Quello che sento é giapponese?

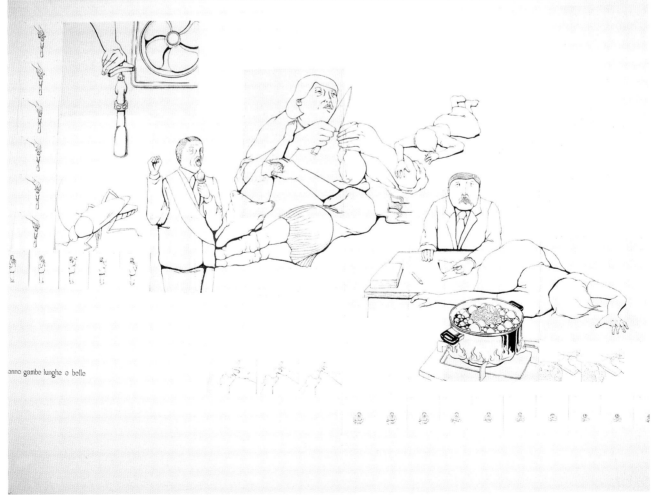

anno gambe lunghe e belle

157

Notes on the Artists

MAKIKO KUDO (b. 1978, Aomori Prefecture), a graduate of the Joshibi University of Art and Design, started exhibiting her paintings in 2002. Along with shows in Tokyo, her work has been exhibited in Los Angeles, New York, and Berkeley. She lives and works in Kanagawa Prefecture.

CHIHO AOSHIMA (b. 1973, Tokyo) graduated from Hosei University with a degree in economics. She started exhibiting in 1999, and in 2000, her work was included in the Los Angeles Museum of Contemporary Art's group exhibition "Superflat." She has collaborated twice with the clothing brand Issey Miyake to create visuals that were the basis for fabric patterns and in-store murals. An artist/employee of Kaikai Kiki Co., Ltd., she lives and works in Tokyo.

YUKO MURATA (b. 1973, Kanagawa) is a graduate of the Tokyo art school Setsu Mode Seminar. Since 2000, she has been exhibiting her work in Tokyo, where she lives and works.

RYOKO AOKI (b. 1973, Hyogo Prefecture) is a graduate of the Kyoto City University of Arts. She has exhibited internationally since 1998. She lives and works in Kyoto.

YUIKO HOSOYA (b. 1973, Tokyo) studied fine arts at Goldsmiths College, University of London. Upon her return to Japan, she worked as an editor before becoming a freelance artist. Since 2000, she has been exhibiting her work in and around Tokyo, where she lives and works.

AYA TAKANO (b. 1975, Saitama Prefecture) is a graduate of the Tama Art University. She began exhibiting her work in 1997. Her monographic publications are *Hot Banana Fudge* (2000) and *Space Ship EE* (2002). In 2004, she continued her collaboration with the clothing brand Issey Miyake to create visuals that served as the basis for fabric design and in-store murals. An artist/employee of Kaikai Kiki Co., Ltd., she lives and works in Kyoto.

CHINATSU BAN (b. 1973, Aichi Prefecture) is a graduate of the Tama Art University. She began exhibiting her work in 2001 with the group show "Beast Festival" at the Museum of Contemporary Art, Tokyo. An artist/employee of Kaikai Kiki Co., Ltd., she lives and works in Tokyo.

KYOKO MURASE (b. 1963, Gifu), a graduate of the Aichi Prefectural University of Fine Arts and Music, continued her studies at the Kunstakademie Düsseldorf, where she completed her master's studies. Solo exhibitions of her work have been held throughout Europe and Japan since 1994. She lives and works in Düsseldorf.

YAYOI KUSAMA (b. 1929, Nagano Prefecture) is a pioneering artist and writer renowned for her soft sculptures, "infinity net" paintings, and installations using mirrors and electric lights. A major retrospective of her work was mounted at the Los Angeles County Museum of Art in 1998; the show then traveled to the Museum of Modern Art, New York, the Walker Art Center, Minneapolis, and the Museum of Contemporary Art, Tokyo. She lives and works in Tokyo.

TABAIMO (b. 1975, Hyogo Prefecture) is a graduate of the Kyoto University of Art and Design. In 1999, her graduation production was awarded the Kirin Contemporary Art Award for Excellence. Her animation has been shown internationally. She lives and works in Tokyo.

About the Author

Based in Tokyo since 1997, IVAN VARTANIAN is an author and editor specializing in drawing, photography, and design. Subjects of his books include the early drawings and illustrations of Andy Warhol and the drawings and watercolors of Egon Schiele.

Acknowledgments

THE AUTHOR WOULD LIKE to extend his humble thanks to the artists who graciously agreed to collaborate in the making of this book. It was a great pleasure and education to work with each artist in the selection of their artwork. Furthermore, I greatly appreciate the enthusiasm with which each artist produced original sketches for this publication. The preparation of this publication would not have been possible without the creativity and efforts of many other individuals as well. My colleague Kyoko Wada provided a wellspring of ideas and insights that helped galvanize the project. Rico Komanoya's care was matched by her speed and efficiency in helping me structure the logistics of this publication. Shuzo Hayashi of Lim Lam Design helped to open up many new possibilities through his graceful book design and layout. And thanks to my longtime colleague Diana C. Stoll, who provided a steady and sensitive hand in refining my writing for this publication.

The following individuals also deserve a hearty thanks for their patience, assistance, and interest: Steve Mockus, Sara Schneider, Alan Watt, and Stephanie Hawkins of Chronicle Books; Takayuki Ishii, Nahoko Yamaguchi, and Jeffrey Ian Rosen of Taka Ishii Gallery, Tokyo; Tomio Koyama, Misako Niida, and Sachie Nishizawa of the Tomio Koyama Gallery, Tokyo; Yoshitomo Nara; Takashi Murakami and Yuichiro Ichige of Kaikai Kiki Co., Ltd., Makoto Aida; Chie Fukasawa and Kaori Hashiguchi of the Gallery Koyanagi, Tokyo; Isao Takakura and Yoko Kawasaki of the Yayoi Kusama Studio; Mayumi Uchida; Kimiyoshi Kodama and Ken Kobayashi of the Kodama Gallery, Osaka; Junko Shimada and Takeo Hanazawa of Gallery SIDE2, Tokyo; Clement Yau and Frankie Lee of Everbest Printing, Ltd.; Yoko Mori; Hiromi Kitazawa of Nanjo and Associates, Ltd.; Midori Matsui; Noriko Miyamura of Bijutsu Shuppan-Sha, Ltd.; Corinne Quentin of Le Bureau des Copyrights Français, Tokyo; Donna Wingate of Distributed Art Publishers, Inc.; Lesley A. Martin and J. Walter Hawkes; Jim, Mary, and Pippin Barr; Miko McGinty, Eric A. Clauson, Valerie Koehn, Julian Stevens, Yumi Shimada, Kenji Miyazaki, and Kenji Kanemasu.

Credits

First published in the United States in 2005 by Chronicle Books LLC.

Text copyright © 2005 by Ivan Vartanian / Goliga Books.

Page 159 constitutes a continuation of the copyright page.

Library of Congress Cataloging-in-Publication Data available.

ISBN: 0-8118-4708-X

Manufactured in China

DROP DEAD CUTE was written and edited by Ivan Vartanian / Goliga Books, Inc., Tokyo.

EDITORIAL ASSISTANT: Kyoko Wada
BOOK DESIGN AND LAYOUT: Shuzo Hayashi / Lim Lam Design, Inc., Tokyo
PRODUCTION: Rico Komanoya
COPY EDITOR: Diana C. Stoll
COVER DESIGN: Sara Schneider / Ivan Vartanian

The typeface used throughout this publication is Mrs Eaves, designed by Zuzana Licko (Emigre), ca. 1996. The display font and page numbers are set in Base Monospace, designed by Ms. Licko in 1997.

Distributed in Canada by Raincoast Books
9050 Shaughnessy Street
Vancouver, British Columbia V6P 6E5

10 9 8 7 6 5 4 3 2 1

Chronicle Books LLC
85 Second Street, Sixth Floor
San Francisco, California, USA

www.chroniclebooks.com

Front cover: Aya Takano, *Waking Up*, 1999. Acrylic on canvas, 33 × 25 cm.
Back cover (clockwise from top, left): Tabaimo, From *hanabi-ra*, 2003; Chiho Aoshima, *Japanese Apricot 2*, 2000; Yuko Murata, *Grown-up Sheep*, 2002; Yuiko Hosoya, *I heard a strange bird singing in my garden when I ran out to see it there was only a Japanese woman whistling who always talks to herself*, 2002; Makiko Kudo, *That Sort of Season*, 2003.